My Life,
My Dreams,
My Desires
(No Deposit, No Return)

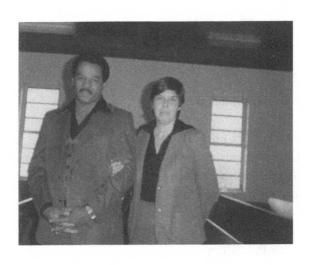

ED BANKS

ISBN 978-1-68517-238-1 (paperback)
ISBN 978-1-68517-239-8 (digital)

Christian Faith Publishing
832 Park Avenue
Meadville, PA 16335
www.christianfaithpublishing.com

Printed in the United States of America

Contents

————— ◆◆◆◆◆ —————

1

Dreams, Desires, and Fulfillment

The choices we make during our lifetime are made in hopes of being successful in finance, finding better career opportunities, changes for the better in overall lifestyle, and/or to elevate our personal status. As we travel along life's highway looking for success, there are many exits along the way. If you choose to take one of those exits, it may lead you to your dreams and desires, setbacks, or maybe an even trade for your current situation.

Though we are not obligated to take any of the exits that life offers, if the road we are currently on is taking you nowhere, it would be advantageous to choose another path. Remember this: Being satisfied with a lifestyle that is undesirable, choosing to not make a change, will lead you on a hopeless and boundless journey. That journey can be compared to having a front-row seat at the city landfill, while waiting for a free meal service offered from the venue.

Over time a serious desire for a change can be snuffed out by complacency. When desire and complacency meet, there is a collision that could nullify any hope for actions. However, acting on your desire will keep you in the right direction to fulfillment and the things that life has to offer.

About dreams, is there satisfaction in dreaming? The most obvious answer is yes! Since we all dream, try imagining what your life would be like without the opportunity of dreams.

This world is designed in such a way that all of us cannot be doing the same thing. Therefore, it is acceptable that even though opportunities abound, there are those who are satisfied to remain in their current situation. However, what happens with their dreams? The drawback to dreaming and receiving satisfaction is that the outcome is artificial.

We may dream of being the president of the United States or maybe living in a world where we are catered to both day and night; nonetheless, the problem is that when you awake or come around, there you are, the same you. Because of that, you may crash and burn, or you may experience a temporary impassiveness to your current situation.

On the other hand, an ambitious desire to be somewhere else or doing something different is as American as the Dallas Cowboys. Dreams and desire are two unavoidable parts of everyone's life. Dreaming arrives at our birth and stays with us till we die. Dreams and desires are partners, and when they arrive, they take us away for a while and sometimes to a destination unknown.

Do you remember when you were daydreaming in class and your teacher called on you and said, "Stop daydreaming and come back and join us!" Though that may have caused an abrupt ending to our mental absence, it did get the job done.

As alluded to before, deep and pleasurable thoughts can carry us far away and sometimes send us into a deep, satisfying, and stimulating daydream. Those thoughts sometimes stick with us all day, throughout the evening, and all the way to bedtime. It is then we dream of that which has captured your mind. When that happens, we have no one to credit but ourselves, for the dreams we have are mostly a product of our own doing.

Since dreams are described as "a series of thoughts, images, and sensations occurring in our sleep," I believe it is safe to say that those thoughts, images, and sensations are a product of our doing. It has been said, "Be careful of what you wish for." However, in this case, "Be aware of the dreams you cause!" At some point in our lives, we all have heard someone say, "I dreamed that the other day, and now it happened!"

When real desire awakens within us, we look for a way to satisfy the desire. Action is the most important thing that will lead us to fulfillment. Without action, dreams happen, and then they die. Action is the demonstration of your need to transform desire into reality. Some of those desires can happen overnight, and others such as education, personal relationships, and promotions, may take some time…maybe even years.

As we close out this chapter, I want to mention what I call "the bonus program." The bonus program happens when we get treated with those emotional, romantic, or successful dreams that we never want to leave behind. Remembering our first love, our first kiss, our wedding, and much more, spices up our world and even helps keep us sane. Referring to the pleasant can make the unpleasant manageable. Without the bonus program, just how boring do you think a day, a week, a month, or a lifetime would be? Enjoy the moment, treasure the dreams, and let it make life a new start every day.

As we begin my story, remember that life has meaning. All of the things we do from childhood to life's departure represent our life. If what we do during that time does not cause you to remember and rejoice along the way, then ask yourself, what went wrong? I have yet to meet anyone that says that they have never imagined or dreamed about life and hoped for the need for change. Have you?

For me, my life story is just as relevant as anyone else's story. It is special to me because I lived each event in the moment, hour, or the days as they occurred. My memory bank is full of both good and bad times, and as a result both my dreams and life mostly flourished. Understanding this, it became important to me that I learn how to influence my dreams. Life has a funny way of making you draw from the bad to make good, and from that good comes fulfillment.

My story is made from a lifetime of memories of family, friends, religion, work, and most of all, dreams and desires. Should you have lived your life the way I have, it has brought a mega of experiences and dreams that will last forever. Someday tell your story about how dreaming caused your life to change.

I want to leave you with one current assenting. On Friday, July 16, 2021, I got to thinking about a very good friend of mine. The

thought of them just kept jumping into my head all morning. So I sent them a message that said, "Thinking of you, how are you?" Throughout the evening I continued to think of them, and I periodically checked my e-mail for a reply. It is now the 18th, and I have not heard from them yet, but on the night of the 16th, the day I e-mailed them, I had a dream about them. It was like a small reunion, and we both got along famously. See, it still works. Now, only that person can validate that I contacted them, and if they read this, they will know I wrote about them and the dream. Yes, I know, it all was artificial!

In the back of this book, you will find a poem I wrote while in grade school. It is called "Fishing Days." My teacher took me and the poem around the school to show it off. There were a couple of verses that had to be rewritten because of memory, but 95 percent of the writing is as it was around 1958. I also dropped a couple small sayings and poems for your review. One of those came in middle school. Guess which one.

These writings are an example of where my mind was taking me while still very young. I remember them just as I remember hundreds of occasions from my life and my dreams. You can do the same. Is your life worth it? Always remember and follow this simple rule: If you do not put something into your life, you get nothing back. Kind of like "No deposit, no return!"

2

––––––– ✦✦✦✦✦ –––––––

Growing Up Poor but Content

While growing up I enjoyed all the time spent with my parents and siblings. Even while very young, I wanted to be around my family. I would play of course, but when my parents and all of us kids were all at home, that was where I wanted to be. With the size of our family, I can assure you that none of my early years ever resembled wine and roses. That meant the joy I had in life would have to come from somewhere else. So when something was going on in our home, the only thing you could do was to jump in and enjoy the ride.

As far back as I can remember, there were days that I went to bed hungry but not starved, wore shoes with holes in them but managed, and dressed in hand-me-downs but rejoiced. Where we grew up, there was the same living situation for most of our neighbors. The main difference of course was the amount of people that occupied the same space.

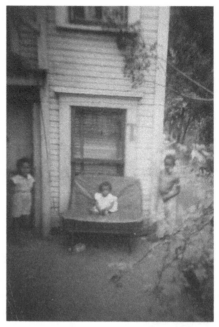

Our second house with three kids playing

It seemed that our lives were lived according to what we were obligated to do. There was not much discretionary time for anything fun or fulfilling. I was too young at the time to have any real responsibilities myself, but I took in all that was required of my mother and my older sisters. I watched my sisters work their way through high school, with most of the time being spent working at our house. They sweated through the hours of summertime and found no relief when the snow came. The hours were long, and the pay was nonexistent. I felt bad when I saw them washing dishes and taking turns fulfilling all the responsibilities that faced them. It was even worse when I looked through the window and saw them washing diapers outside in the snow.

The family's week was full of obligations to the church and the home. Family, chores, school, and religion represented our first alma mater. The school of hard knocks was a serious thing in our house, and lessons we learned about life and family cut deep into our being. All of us graduated that school with special honors. Because of those

individuals in our small town that were blind to color, we were able to survive and earn the choice to follow our dreams.

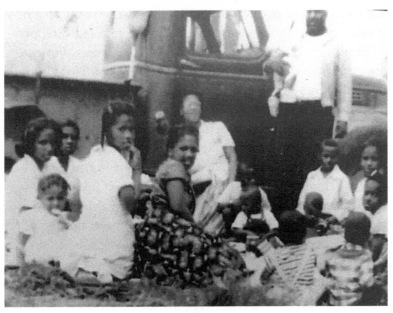

Our family at a church picnic, fifteen of the nineteen kids at the time

Over time our family grew to a total of nineteen strong. There would be ten boys and nine girls, all of us to the same parents. There would eventually be three sets of twins, with the first set being a boy and a girl, the second two boys, and the final set two girls. As the family grew, we entertained ourselves with a rhyme made from all of our names. It would start out with the oldest and wind down to the baby. We did include my parents, so we would say as fast as we could, "Daddy [Edward H. Banks Sr.], Momma [Ora Pauline Banks], Scooter [Mary], Nettie [Janette], Tootie [Mildred], Winnie [Edwina], Hope, Duno [me, Edward Jr.], Mike, Gene, Connie, Peter and Reggie, Timmy, Paul and John, Phillip, Ora, David, and Pam and Tam."

At the very end of the jingle, we would say, "And sometimes Kim." Kim was our niece and the daughter of Nettie. She was born very close to the time Pam and Tam were born, and she spent a lot

of time growing up with us. It was only appropriate that we included her in our rhyme. So the kids number grew to twenty with Kim. The kid that could say the rhyme the fastest would win. There were a lot of nicknames in the rhyme, but that was how we were called at home. The twins of the family are the three names connected with *and*.

Family nicknames just kind of evolved, I guess. For me, the nickname *Duno* came from my sister Hope. When I was born, she had a hard time saying the word *Junior*. When she said Junior, it came out Duno, so that was how I got the nickname. I cannot tell you how the older kids got their nicknames, but they lasted forever also. Regardless, there was no confusion when being summoned by the parents. Whenever they called your name, you had better be on your way before the sound of your name left their lips!

Through all our trials and tribulations, one thing always stood out, and that was the fact that we were family and no one or anything came between us. I am sure a lot of people can say the same thing; however, we had no choice but become close to each other. We were siblings no matter the issue, and everyone was committed. No one was left behind even on Sunday mornings, Sunday nights, or Wednesday nights. Each year new babies were welcomed at the church through a ceremony called "a dedication." From there, they officially took their place on the church roster.

The older girls raised most of us from birth and held and watched us during church services. No matter how much anyone wanted to complain about anything, we seldom did. I could never have stood all of what they had to do, you got to hand it to them. When the work was hard and plentiful, they worked their way through all that was needed done by singing songs. My neighbors and friends commented constantly about their harmony in the different vocal parts as they sang. They were often called the Supremes, as a reflection of the real group. They did sound good. When they did music specials at church, the babies were even quiet. No one could ever forget the harmony.

The church was full of talent, and two of my dad's sisters and a brother belonged to the same church, and they could really jam! Instruments and voices were prominent in the church, and special

music was available at the drop of a hat. The real treat came on a night that was called missionary night. It was like *The Ed Sullivan Show*, and it seemed like that the whole church participated.

Missionary night happened during the months that held five Sundays. The bulk of the evening was dedicated to song, poems, and scripture readings. The collection that night went to funds for missions that were chosen by the church leaders. Services were always longer on missionary nights because there was preaching after the program. You know, no one really minded. Neither did I.

Our family, including the relatives, were very musically inclined and liked to use their talents. At home and for entertainment, we would sing and tape-record the songs. Sometimes our uncles, aunts, and their children would participate. Those times were very special, and all of us learned the value of family through the times that we spent singing and playing music. Sometimes people would bring food to the recordings. That was extra-special. As we got older, some of my brothers and sisters picked up playing instruments, but I only caught on a little bit.

My dad worked for the railroad and spent a lot of time during the week working from camp cars. When he was home, in the evenings we would also spend time reading the Bible together. We read the Bible cover to cover at least once per year. Our social life outside of the home mostly consisted of church picnics, ball games in the backyard, or visiting our grandparents.

My most favorite times of the year came with the excitement of the holidays. Holidays brought Easter egg hunts, gifts from the church, and Christmas stockings that were filled with candy and fruit. For the most obvious of reasons, Christmas was my favorite holiday, but with nineteen kids, money and gifts were not so plentiful. We were all given the opportunity to make a wish for one gift, and somehow our dad responded favorably.

Thanksgiving was nice too. I can remember my dad coming home on Thanksgiving eve with a live turkey that had to be plucked and cleaned for the next day. One special Thanksgiving, my dad said he was going to help cook the meal. He volunteered to make the pies. Each year the pumpkin pies we had for the holiday were made from

scratch. That meant that the pumpkins had to be cut up and cleaned and cooked to the right thickness. My mother said that my dad had made the filling too thin, and she got upset and disappeared somehow and somewhere. She was protective of her kitchen and was not happy about my dad wanting to help with the meal. My dad eventually got the filling where it should have been, and the pies turned out okay. He never volunteered to help with the meal after that.

Now there was a trick to getting all of us around the table for meals. To make it possible, my dad got two four-by-eight sheets of plywood and framed them. Here is the neat part. He put the two sheets together with hinges so the table could be folded and sat against the wall when not in use. I thought that was so creative.

When we were ready to eat, we put the table on two home-made sawhorses, and we were all able to sit and eat together. Just as a sidenote, if you are wondering about table settings, we made do with what we had. Some of us used forks, and some used spoons. In serving the drinks, we drank from tin cans and were thankful that we had them.

Back to my favorite holiday. Christmas morning always started out the same. We continually asked our parents if we could get up and unwrap our presents. The answer was always the same: "Not till the house warms up." In our first home I remember that there were at least four rooms, a small kitchen, a small living room, and two bedrooms. The entire home was heated by one warm morning stove. So my dad would get up and pour coal on the stove, and we waited and waited for the stove to do its job. When it was warm enough, my dad would say, "Okay, you can get up." It is a wonder the house stood up under the thundering of all of us heading to the living room and to the Christmas tree. Sometimes the gifts were wrapped and under the tree, and sometimes our parents hung them on the tree. No matter, the important thing for us was getting the presents.

As it got close to Christmas, my day would take a ten-pound lard can and start filling it with hardtack candies. Ribbons, crème-filled candy, and just about any variety of hardtack you can think of went into the can. The night before, my mother had also spent her evening in making pumpkin pies, apple pies, and homemade fruit-

cake. My dad would top off his shopping by bringing oranges and apples home. Following the evening meal, we would eat deserts. As I recall, the only times we had a desert with a meal was at Christmas and Thanksgiving.

On the Sunday before Christmas, our church would give treats in containers shaped like stocking to all the kids twelve years of age and younger. That was another great thing about Christmas because they spared no expense in providing small gifts, fruits, and candies that would last a couple days. Now are you beginning to see why I like Christmas the best?

The time spent in religious services had our family in attendance at least six days a week. On Sundays, we had Sunday school, followed by morning preaching, and then an evening service at seven o'clock. On Monday evenings, there was what was called "the little soldiers' meetings." Little soldiers' meetings were limited to kids twelve years of age and under. In those meetings, the kids would memorize Bible verses, sing hymns, and receive a devotional. On Tuesdays, there were prayer meetings, and on Wednesdays, there were traditional evening church services. On Thursdays, there were no services, but on that day the men usually performed needed repairs to the building.

When my brothers and I became old enough to work, we became part of Thursday nights. The women of the church sometimes held sewing circles or some type of social gathering on Thursdays as well. On Fridays, there were "young people's" meetings. That service was for those thirteen and older, and the service mirrored the little soldiers' meetings, but on a much higher scale. On Saturday evenings, there were brotherhood meetings for the men of the church and their sons. To this day I do not know how I got through all that church time and still completed my homework and chores.

Even at an early age, I spent a lot of time in thought of how it would be when I was on my own. Like all of us, I did not know what might lay ahead, but I knew that I needed something different. I wanted the same type of family life, but without all of the time in church. Mostly, I dreamed of one day having a wife who was like my mother and a family of my own, but not with nineteen kids. I thought my mother was the best in the world. She was stern,

but since she mostly ran the home, she seldom deviated from her schedule and rules. For years she managed the budget, baked bread, supervised the care of the babies, directed the cleaning of the house, and repaired our clothes. One of her most favorite job was assigning the new babies to my five older sisters.

To this day, I can remember our first washing machine, our first telephone, our first television, our first truck, and so many more things that made our life so different and more interesting than anyone I knew. As tough as things were for all of us, on rare occasions my parents would try to be funny. Them trying to be funny was the most entertaining thing about the occasion. I really do not think that they knew how to be funny. Imagine having all of us running around playing and carrying on. No laughing matters.

Across a small creek were neighbors that attended the same church. They were very good friends of our family. My dad was friends with their dad, and my mother was good friends with the mother. Of all friends, they were the ones that kept our lives busy when outside. We did lots of things together and grew up in school with the boys. Their ages matched our ages. They also had a sizeable family. There were eight boys and two girls. Sometimes my mother would go out in the backyard and shout "Yoo-hoo, Ozzie!" to the mother, and they would talk back and forth about different subjects. I think they enjoyed the out of doors talking, because we both had telephones. I guess that it was a way of taking a break from all of us.

With one of their kids being the same age as one of us, that meant that one graduated with one of us. That was neat, because there were two occasions where we could share information on a daily basis, and that was church and school.

3

School Days

When I began grade school, I was happy with the opportunity to socialize and hang out with newfound friends. Because of the time we spent in church, outside of family, I was more interested in talking and getting to know my new friends. I hardly ever gave learning the attention needed academically, and I was called out for talking several times. The friends that sat around me in the classroom did not mind, so what was the big deal, Teacher?

Talking with my friends was great, but my favorite thing was recess. I could not wait for the recess bell to sound. Before the moment we were dismissed, I already had my mind and one foot out the door.

Let me tell you, recess was the bomb. I got to see and make more friends from other elementary classes. Recess also provided me the opportunity to peek and check out the fifth and sixth graders. From them I learned how to act and be favorably known. The six graders were the rulers of the playground, so it was from them that we learned how to mimic their actions when we became their age. I was fortunate in a lot of ways when it came to playing at recess. Eventually, two of my brothers and two cousins had started school and were on the playground at the same time. That gave us some credibility considering the numbers of us that were there. We always had each other's back during that time. Life was great at recess time,

17

and you can be sure that all issues with study and education went away when we were on the playgrounds.

In our town there was a children's home, and all the kids that lived there came to our school. They were the nicest and friendliest kids in the entire school. We all got along well with them, and they had no enemies in the entire school. I will never forget the kids that I became good friends with. It seemed that all the kids, both boys and girls, were good athletes. We played football sometimes at recess, and there would be an argument about who would get the kids from the home on their team. Honestly, I would look at the kids as they played, and I would think, "Who likes going to school more, them or me?" It also seemed that all the kids had nicknames. When the teacher called the roll and call them by their given names, I would look around and think, "Who is she talking about?" When they raised their hands, I would think, "Oh, okay." We still called them by their nicknames though. I can still remember their names.

I would be leaving a lot out if I did not mention the art of playing it cool and acting out for the girls during recess. Of course, back then we did not even know what relationships and real girlfriends were, but we sure knew what pretty was. Playing tag was one of the favorite games on the playground. In playing tag and being chased, we tried to be the fastest runners, especially when one of the girls was tagged.

We sometimes even let them tag us. When a boy was it, all bets were off and our super-abilities kicked in and we outmaneuvered their every attempt to tag us. Another thing we did during recess was to get in the middle of the merry-go-round and push the girls real fast and make them scream. Being in the middle of the merry-go-rounds was strictly forbidden, so we had someone stand guard for teachers or playground supervisors when we pushed from the center.

There were two sliding boards on the playgrounds. One was a short slide and did not stand very high, and we said it was for beginners or sissies. The second was a very tall slide, at least it was at our age. Honestly, when I saw the slide, it took a long time and a lot of courage to climb that tall ladder. It seemed like forever. After I overcame the fear, we would do stunts on the big board.

Once we were over our fear, we would go down backward, on our stomachs, walk down, or bound together by our legs or arms making a train. Only the brave would climb and attempt those feats, or so we thought. While being good sports, sometimes we would volunteer to sit in front of the scared girls and control the speed of the decent. When we did that, the hero points would really rack up.

The playground also had two sizes of swing sets, and they were a whole different issue. There were two ways to use the swings. One way was to push girls for points or push other boys as high as we could for showing-off purposes. The bigger of the swings presented a challenge. The boys tried to push each other high enough that we would go all the way over the top support bar. Once you had someone up so high that it looked like they may go over the bar, the entire playground stopped, and all the kids would form a circle around the swings. They would gaze in anticipation of "Is this the time it happens?" To my knowledge that never happened, but it was fun trying. As for pushing girls on the swings, it was the best and the most enjoyable time because they would always say, "Faster, higher, faster, higher!" We would do our best to oblige.

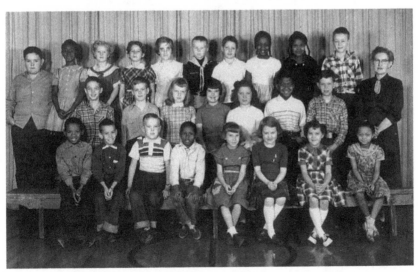

First-grade class with me at the first row on the far left, and my brother Mike in the middle of the first row

All through my younger years of going to school, the second best overall thing came when we walked to school in the morning and back home afterward. If you were lucky, you would get to walk with a girl or another close friend until we got to their street. Sometimes it would be your unfortunate duty to supervise the walk home with a younger sibling. Whether walking home with a friend or family, the walks go in the books as a good memory. I will never forget the conversations that accompanied the walks. They mostly would contain topics of favorite cartoons, Superman, Clutch Cargo, Sky King, the Mickey Mouse Club, Johnny Quest, Captain Kangaroo, and an ongoing extended list of the '50s and '60s family and kids' television shows. Regardless, and as you can tell, the walks and the conversations provided a lot of material for thought. They were also inspirational in provoking imagination and making dreams.

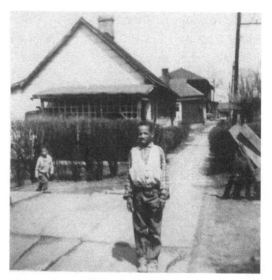

Me in front of our house at eleven years old

The early years of education also brought one of my most traumatic experiences. It was summertime, and while my dad was away at camp cars for the railroad, I went into his radio and television repair shop and messed around with everything I was not supposed to mess around with. One day I found a five-gallon can of liquid that

I did not know what it was. I decided that I needed light to find out what was in the can. I found some matches. I opened the top and struck the match. That was the last thing I remembered for a few seconds. When the pain kicked in, I took off running and screaming. Man, did I hurt. My face was all blistered, and the skin was hanging down from different places on my face. I learned later that the can was filled with kerosene, and it exploded as soon as I lit the match due to the heat in the shop.

Though I was suffering, my mother had no sympathy for me. She told me that I should not have been in the shop. On top of that, she told me I was not staying home from school, and I was going back the very next day. After I got dressed for school and still in pain, she put a baby's cloth diaper around my head, something like India headdress. The only difference was that my face was completely covered, all except for my eyes. When I got to school, my classmates did not laugh at me; in fact there was a lot of sympathy for the incident. My teacher was the most upset. She took me by the hand and showed me to all the other teachers in the grade school classes. Then she took me to the office, and I was sent home. Besides the pain, the event left me very embarrassed.

Over the weeks that I was home, kids would come to my house to see me. For some reason, my mother was more than willing to show me off. My brothers would ask me to pull some of the skin off my face to show the kids what it looked like underneath. I did and maybe that helped to prevent long-term burn scars. When my dad got home and saw me, he was a little more sympathetic, but more of "Stay out of the shop when I am not home!" When I healed, I returned to school and picked up where I left off through added homework.

4

Middle School

Middle school gave a whole new meaning to the words *school* and *education*. That sometime pity that you got from grade schoolteachers and the light homework assignments all went away. There was the changing of classes, the changing of teachers, and more difficult subjects that were all just a little mind-boggling. There was no time to mess around, joke around, or for slacking your way through those two years. You were alone in your studies, and you either made it or you fell by the wayside. We still had the walks back and forth from school, even though the topics took a little different tone. The occasions brought food for thought and plenty of material for dreams.

As seventh graders, our observing student behavior had now turned to watching the high school students. If there was a way to learn a new style of dress, smooth walking, slang, and appearing big and bad, we found that the opportunities were plentiful. Also, as they were upperclassmen, we were very easily intimidated. In the first place during seventh grade, you usually had to literally look up at the upperclassmen when you had a conversation. Secondly, being smaller than most, we had our health to consider.

By now I was able to see my older sisters as they moved about to their classes. Sometimes they would introduce me to their friends. Even though 95 percent of them were girls, at that time I thought they were too old to bother with or remember. Really? The more

athletic upperclassmen were people I thought that it was my duty to speak to and become friends with. Afterall, it would be those guys we would hear about on Monday morning. If someone had scored the winning touchdown, shot the winning basket, or broke a track record, I would act proud and say, "Yes, I know them."

A second bad time for me came when I was in junior high. Twice I became sick with my throat as it swelled to the point that I could only manage to swallow small drops of orange soda and only occasionally. My mother called the sickness "quinsy." I had no idea what that meant or who quinsy was, but I cried every day, sweat, and could not get comfortable. I was not taken to the doctors, and the illness lasted for weeks. I lost a lot of weight during that time, and I really was miserable. I eventually got better, but the same illness returned the next year. This time it was a little easier to take and didn't last long. I did not get as many visitors as the first time around, but I did get notes from my classmates. It was also terrible hearing my brothers and the neighborhood kids playing ball in the backyard and not participating. However, I was too tired and weak to even look out the window. Once I got back to school, I went to all of my friends and told them how much I missed them. We were melancholy for about an hour, then we laughed and were back to business.

Structurally, between the grade and junior high school and the high school buildings, there was an open breezeway. That was officially where you got the job done. When classes changed you would look for that special person that you wanted to see. Many a note or letter were passed in the breezeway, and a rejuvenation of your soul spewed out tiny hearts that spilled all over the paper as you read the content. Also, if there was an issue between classmates, when they met in the breezeway, you could see the posturing that took place. If more time was needed, you met after school.

Though limited time, it was also there that you worked out all your issues if possible. If not, a time and place for the fight was set. Every student in the school seemed to have gotten the word: "There's going to be a fight after school!" Fortunately, most of the time things had a way of being worked out before three thirty. In my years of schooling, I unfortunately had to duke it out a couple times, but I

think that happened to establish a reputation; at least for one of us, that is. Saying things about one's parents or family sure would get folks riled up and spitting nails. Do you remember the song "Don't Say Nothing Bad about My Baby?" There you go. That saying went for any family member, girlfriend, boyfriend, or any close friend. I am very glad for my children and grandchildren's sake those ways of settling things have almost completely passed.

As mentioned earlier, a new value to my walks to and from school was formed. Now there was a completely different and more lifelike subject matter. The walks were also sometimes used as a deprogramming tool whenever the day was not so good. It appears early adulthood had ruined a perfectly good lifestyle. Now during the to and from walks, the subject matter had turned to school dances, youth center, relationships, cars, driving, world news, and all sorts of other socially enriching topics or events. Now when we reached the streets where we said goodbye, we realized that our parting words had turned the page toward a major chapter in our lives, whether we wanted to or not. It was more like "See you later" or "Have a good one!"

As we prepared to leave middle school, we left with our main core of friendships. I still had my chores to do, and I knew saying goodbye to middle school meant it was now a time to buckle down even more, continue to grow relationships, and face the future as a freshman.

5

High School and More

High school was good, but it also brought about a surprising realization that my first year would not be the same as my brothers and my friends. In my freshman year, my brothers and I were not able to play sports because of our church. I think we knew that, but we were hoping for a change of heart from our parents. The reason given to us for not playing sports was that there were people betting on sports and the athletes were no more than pawns for the bets that were made. Regardless of the reasoning, our friends were all playing sports, and they kind of let us know that we were different because of our church.

I soon learned that being in high school also was kind of like being part of a sorority. We could not play sports, but we sure did cheer the athletes on during the pep rallies. Man, the fun! The cheerleaders were jumping and screaming, the students were shaking their fist and screaming, and the administration smiled. I had never in my life seen anything like that. I had watched college and pro sports on television, but this was so different, mainly because I was there to see it and be part of it.

I remember that during the year we got a new superintendent and during one of the pep rallies, he went up on stage and led a cheer. That really was something, and we all let him know that we appreciated his enthusiasm. We all clapped, screamed, and jumped up and down. The noise was so great, I know that the elementary side of the

buildings was wondering what was going on. Along with the pep rallies there were periodic assemblies announced over the public address system. Sometimes it would just be the juniors and the seniors that were called, but for the most part, they were for all of the high school.

Another neat thing about being in the auditorium as a high school student was the way in which we were dismissed. Sometimes the cheerleaders would say "Two, four, six, eight, who do we appreciate?" The student body would reply, "Seniors, seniors, seniors!" With that, the seniors would get up and leave the auditorium. The cheerleaders would do the same thing for the juniors, then the sophomores, then finally us. I know it sounds stupid, but we were all pumped through the process. Give us a break, we were just freshman!

While I was enjoying the pep rallies and the assemblies, the rest of the high school was planning and doing other things like dances, plays, homecoming, and prom. Of course, you guessed it. Because of our religion, all the activities were off-limits for us. We only enjoyed them from the stories that were told the following school day or as we walked home with a friend. By now the names of "holy rollers" and other churchgoing names were being used by lots of people, including our neighbors. It was a little tough.

All the things we were beginning to experience as high school students were good. There were even track meets during school hours. We would sit by the window and watch the guys compete. I do not even think there was girls' track then. I did not see any girls' events going on; however, there was girls' basketball. It was girls' basketball played completely different from the way it is played today. There were three girls on one end of the court and two girls on the opposite side of the court. They could not cross half court. The defense would rebound and throw the basketball to the offense for them to try and score. The game was played that way for a long time.

Academically, you had to know what you were doing when signing up for classes. I learned that to graduate, you had to have a certain number of credits and you could pick the subjects you wanted. Of course, you had to start your credits selections with the mandatory subjects, and from there you elected based on the credit value. I just had learned something very valuable, and it made me feel good. So I

thought to myself, if I carried a little over three credits per quarter, I could make it. I did a neat thing though. I scheduled myself subjects in the morning and scheduled all study halls during the afternoon. That meant I got all my homework done before the final bell. It also meant I did not have to carry any books home. I was able to get by the freshman year and was now about to become a sophomore.

There was some good news that went with becoming a sophomore. By the time I returned to school for the new year, my dad had taken us out of the church. The reason we left that church was because there was a disagreement on what the scriptures meant. I did not know the reason, and more importantly, I did not care about the reason; I was just happy. Getting out of that church now meant that there would be some freedoms. However, we all knew that our parents were not going to turn us loose on the world without screening our movements, and we fully understood why.

Our first order of business was to attend some sporting events. My brother Mike and I went to our first football game. We sat in the front row and took in all the fanfare and excitement of being part of the student body. It was there that I got to see my first live touchdown being scored. I do not know how I remained seated. The score covered about sixty yards around the left side of the line. I can still see the score being made. I knew the running back, we were friends. *Wow, I have missed a lot since junior high,* I thought to myself. The crowd at the game, both visitors and home side, got into every play. The boo-birds came out in full force when the officials dropped the penalty flag, and the fans who got the benefit of the call cheered. I could not help but notice that all my friends were there. I thought, *Now I can be one of the people who will talk about the game on Monday.*

My brother and I did not have a lot of money, so we did not visit the concession stand. As a matter of fact, I do not think we left our seats, and that included during the halftime show. One good thing about attending sporting events was that the school patrol boys got into any school event for free as payment for doing the job. All of my brothers became patrol boys. We monitored the halls, ran messages around, and more importantly, stopped the traffic for the

kids to cross the street after school. It was fun, exciting, and a little respectful.

On Monday when we went back to school, there was one other thing we learned from our friends about football games. That was sitting down for a football game was not cool! If you want to be in the heart of the action, you must stand behind the main bleachers. From that position you can see who is coming and going and check out the girls as they went to the concession stand. One other tip was that you could pick up important information about who is doing what tonight and where after the game. They were right, and I never sat down again.

Becoming a sophomore had already returned some heavy dividends, and I felt that I had earned the benefits. Dances, basketball games, bonfire nights, and snake dances from the square, and much more became part of our newly found social agenda.

The junior year started out kind of mellow. That was because all the other things we picked up over the past four years, including middle school, were starting to become kind of repetitive. With this in mind, I could not help but feel that something was missing, but I did not know what it was until later. Along with the goings on becoming repetitive, a third major blow was dealt during the summer. Of all things, my parents had decided to move to the country, and it was very soon that I learned that living in the country was not all that. That thing about "blue skies and wide-open spaces" was partially true. The wide-open spaces did exist, but seeing blue skies, not hardly. The move was quite a surprise, and besides, I had a lot of junior-year stuff to experience, talk about, and do.

I know that there was really nothing wrong with living in the country. A lot of the students in my class and the class behind me lived in the country and rode the bus. It is quiet and peaceful there, and the neighbors, what there was of them, really brought out the welcome wagon for our family. Instead of quick trips uptown, riding around, and getting into backyard ball games, we got wooded areas, gardening, and splashing in ponds. All in all, though the move was a social setback for me, my parents were happy, so all of us kids bit the bullet.

On the upside of the move, the house my parents bought was pretty nice both inside and out. To date, this was the nicest place that we had ever lived in. There was a long back porch that wrapped around the house and overlooking a heavily wooded area. There was a full basement, and the coal furnace did not require all the work we were used to in town. The coal was feed by a stocker, so all we had to do was take out the ashes. My mother liked the kitchen, and my dad built a wall to put a nice-sized master bedroom on the first floor. My mother like that too. The three bedrooms upstairs had plenty of windows and living space. For our first nonrented home, the house was not bad at all.

Contrary to the many neighbors we had in town, there were neighbors to the right of us and directly across the road and in front of our house. In total there were seven houses on top of the hill where we lived, but besides our family, there were only just as many kids. My younger brothers and sisters made new friends quickly, and you could hear them playing outside just about every day and into night.

From our location there was an option on what school we could attend. Once we walked to the bottom of the hill from our house, there were three buses waiting for our choice in which school to attend. Since I was now a junior in high school, I was not changing schools, but my younger brothers and sisters all opted to go to a different school. That saved me from having to watch or supervise them back and forth each day. It just so happened that one of my core friends lived just up the road from us. Without asking, he volunteered to pick me up every day for school and bring me back after school. How wonderful that was, and how kind is that? His dad even let him drive his new Cadillac to school. I felt extra good about having him as a friend, but I had always felt that way. He was a real cool guy, and his family did not have a prejudice bone in their body.

The more I was involved with friends and the favorable things that life gave me, the more curious I was about how it happened. I was curious about two things: why I liked it and how soon it would happen again. I learned a lot by being curious, but as they say, "Curiosity killed the cat," and I guess that at times my curiosity got me close. Speaking of sayings, as I got older, I decided to avoid living

by the saying "Experience is a good teacher, but a fool learns no other way." I was now trying to be in control of everything I did.

After I had put little effort in my first two years of high school, I decided to buckle down the last two years. It was not because of pressure, but mostly because I liked one of my teachers. She was mean, and she demanded a better attitude toward studies. It was then that I said "Why not?" and I gave it my best effort. I did so well in one assignment I can remember that one day she came to my desk, slammed the paper down on my desk, and said, "Okay, Mr. Banks, who did this assignment for you?"

I was embarrassed, scared, and a little insulted; however, deep down inside I was saying "Yes!" I finally did something that was so good that it was better than I had ever done, and according to my teacher's reaction, it was too good for the slacker she thought I was or, should I say, used to be.

After I got my driver's license, I drove my dad's panel truck to school. It was one of those late but great three-on-the-tree style. He later got a used pickup truck, and I drove it too. Partway through the year he let me drive his car to school since he was away working a lot. That was a good feeling, but it did not last as long as I thought it would. One day when driving home after school, I got cute and decided to show off.

While heading out the street that led to the country, I punched the accelerator and flew by some of my friends. I did not make it very far; in fact, I loss control and hit a telephone pole. I was confused about how I could not control the car. It seemed like it would not stop, as I literally stood up on the brake pedal. What we learned later was that when I hit the accelerator, the linkage on the carburetor came loose, causing the car to run at a wide-open speed. I was fortunate not to receive any serious injuries, but the accident temporarily ruined my driving back and forth in the car. I was now back in my friend's car, but not for long.

One day my gym teacher asked me to go out for track. Following my parents' approval, I agreed. That meant that I was out of the Cadillac again and looking for transportation to and from practices after school. A preacher friend of my dad sold him a 1955 Buick that

I was to use for transportation to and from school and track practice. The car cost an overwhelming forty dollars. Back then, forty dollars was a lot of money. The body of the car was in perfect shape, and so was the interior. The only problem with the car was that the automatic transmission slipped between second and third gears. I worked that problem out by guessing when it should shift to third, and when I felt it was time to shift, I moved the shifter to neutral, then shift quickly back to drive. That worked out the shifting problem, and I enjoyed the experience of owning my first car.

However, with a car comes other responsibilities. The difficult part now became finding a job to give myself spending, gas, and dating money. You know, it is odd that the people who laughed at us and called us holy rollers slowly became our friends. Not all of them, but enough to start conversations with and occasionally visit. There were some who kept their distance, but that was a good thing. We were able to get on with our life without them, and we enjoyed the freedom to choose friends.

Steady dating kind of sneaked up on me in my senior year. I really was not ready for it, and besides, I enjoyed doing things with a lot of my friends, not just one. That thing that I felt was missing during my junior year, I think I found it, and I soon learned why I unconsciously avoided it.

Since movies, dances, and parties were where my friends and I spent most of our time out, we were able to come and go as we pleased, and the best part was meeting new people. A bonus to all of that was, since the rest of my family went to different schools, I had the opportunity to go out with their friends who were introduced to me, and that was especially nice. It was a good thing because dating people from a different school, they could not talk to my friends about it the next school day and I was not able to talk about them at their school. I did meet some nice girls from schools in the surrounding area where we seldom had frequented. My first and second steady dates were that way. To date, that had become just about the best times of my life, or so far anyway.

Monday night roller-skating brought me face-to-face with some of the most beautiful girls I had ever seen. They were strangers, and

it was nice to be able to meet new people, especially pretty girls. Like an eagle surveying his hunting ground, I zoomed in on the prey, and the first one that shared a smile with me worked her way toward me. We talked for a while, and then she told me that she was there with someone. Seemed like he did not mind that we talked. As a matter of fact, she later introduced him to me. We went on spending the night exchanging glances and smiles when we could, and just before the last skate of the night, she came over to say goodbye. She took my hand and slipped me her telephone number.

A few days went by, and I finally called her. You have to remember these were the days that when you wanted to date someone, you had to go to their house and meet their parents, especially the father. You were required to sit and watch family photos presented on a slideshow, tell them all about your family and your future plans, and promise to be honorable with their daughter while in your care—all of that before getting the approval to take her out. It sounds funny today, but honestly, I did not mind. I enjoyed the time with their parents, and it gave me the feeling that they really cared about their daughter. After getting permission to date, our first time together was at a county fair. The night was really nice, but I kept looking around to see if maybe her parents were somewhere watching us. They were not, thankfully. Do you know that song that had the words that said, "Skin brown as the sand and soft as the shore?" I think I dated her.

The second girl I steady dated I met at an away football game. She also met the description of the girl I first steady dated. I remember when I took her home to meet my parents, my mother was all over her with compliments. She was very pretty. My dad just smiled and said hello. My brothers checked her out too. Eventually my brother Gene started dating her sister.

Our first date was to go to a dance at her school. She introduced me to everyone and spent the night showing how happy she was to be there. In my mind I was hoping that she was happy because she was with me. Turns out her good-natured attitude was not a show; she was like that all of the time. Her parents and all of her siblings liked me as well. Her siblings would often call the house and ask for me. They would ask when I was coming over, because I would

take them for a ride when I went down to their house. It was a good relationship.

There were other steadies, but I will not bore you with the details. Just remember, this was long before the time when I met my future wife, Mary, and that meeting remains a game changer for me. I had long already formed the idea of what my wife would be like, and the one with all of the things I desired would have the edge.

Besides dating, there was another kind of nice and interesting thing that happened between my brothers and cousins. Since we were going to different schools, that meant that there were times our schools competed against each other. That happened mostly for me in track and field. We would run against each other in the 100-yard dash, the 220-yard dash, the 440 relay, and the 440 runs. Though I was never defeated individually or as a team against them, I felt bad about seeing them cross the finish line after I did. My brothers and a cousin got the opportunity to play football, so I got to watch them play against my school.

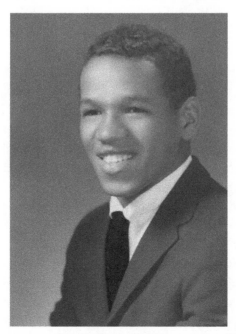

My Graduation Photo

6

Dream Zone

As growing up brought so many challenges and interesting things, I had noticed that when I talked to my friends, they, too, had their own wishes and desires. All of the times that we were together, the dreams were shared one after the other. One would say "I want to do this," the other would say "I want to do that." Somewhere down the road, we all realized that there must be more to experience. Undeniably, our desires were fed by influences from people, television, radio, individual experiences, and observation. All that set our minds in motion, and some portrayals through daydreams and nighttime dreams showed us that it could be possible. In dreams you could visualize the uniform you would wear, where you would live, what position you would hold in your chosen vocation, and all the other things that are part of new beginnings.

Along with dreaming about my future, I would also dream of ways to accomplish my goals. I would also daydream of all those things that were missing in my life and how I could accomplish them. In the process of all this, I did learn early on that my daydreams would sometimes be just okay and nothing special, and I accepted that. Not all desires are going to come to pass. Remember that.

Some of you may have already experienced a good dream that came true. I am sure you put the effort into making the dream a reality and can testify to the effectiveness. Not all the results of our desires are tangible, nor does the product of the desire have to be

34

permanent. For example, as in your desire for a relationship that will last forever, as difficult as it may be to accomplish that, it is your obligation to make it come out okay. Maybe it was not supposed to be, but if you really want something, always remember, "No deposit, no return." Put all you have into the effort. For me, I have fallen short in my lifetime, and it was my fault.

In my teenage years, I learned that my daydreams would sometimes generate the content of nighttime dreams. As a result, I created a completely happy and satisfying life through my dreams, and that continued for a long time. Looking back, it was also made clear that my real life was once part of my dreams. If things got bad, it was up to me to sort out those consequences, while trying to stay in the right lane.

It was also during my teen years that my nights began to be filled with prosperous dreams. Each time I took a particular thought to bed, the dreams flourished and the nights became wonderful. Though I did not always achieve the content of my dreams, the portion I did receive was close enough to my wants and desires. I was happy and thankful for that, and that brought satisfaction, even though the life and the outcome of the dreams were all imaginary or artificial.

When I was thirteen, my desires brought me my first job. I wanted to work so that I could have my own income. I appreciated what my dad gave me for helping in his shop, but I wanted a little more. Once I started to work away from home, there were bonus benefits that came my way. To start with, working out in public created more friends and a satisfactory personal status for my age. I really didn't realize it at the time, but since my parents directed my life in general, no one or anything would control my dreams and their benefits but me. I guess it was a confirmation of some sort.

When I entered young adulthood, my dreams were split between wonderful, dramatic, sad, and fright. Yes, about the time I met Mary, I was still dreaming. Also, the dreams of various things had begun to happen. Those dreams were more about successful people like athletes or teachers, and they happened on their own, especially when I was too tired to put the effort into thinking. I enjoyed my dreams

of prosperity, and now the dreams were manifesting naturally. The things I did and the things I failed to do became my dreams. It was now certain for me that what I thought or desired eventually was seen in my dreams.

If I was to compare those dreams to something relative to today, it would be the ads that are now popping up everywhere over the Internet. If you surf or concentrate your searches on a certain product, the advertisements for that product start popping up everywhere. This is more evident on social media or the shopping apps. Of course, we know that is explainable because our personal information was unwillingly put up for sale. For me, that's what happened with my dreams. I think of something, then I dreamed of it.

There are also those dreams that will really set your mind to churning. Those dreams come with an action or thought that validates the happening. Let me explain. One night I had a dream that we were playing baseball and I ran to catch a fly ball, but I missed it and it hit me in the chest. Here is the kicker: The second that the ball hit me in the chest, one of my brothers rolled over and hit me in the exact area of my chest where the ball hit. Weird? Yes! That kind of thing will have you uncontrollably sitting up in the middle of the night. Have you ever heard someone talk about falling over a cliff in their dream and then rolling out of bed at that exact instant? I have.

As kids we loved to watch cartoons, almost as much as we watched Westerns. On Saturdays especially, when not doing chores, we watched a lot of television. I can remember that I was sleeping one night, and a small platform came out of the wall and a cartoon character came out of the wall and started dancing on the platform. I can tell you that he was wearing a sailor's suit with a bright-red necktie.

When he finished dancing, he went back in the wall and the platform followed him. That dream was as real as me telling you that I was once born by my mother. Before you start thinking about how messed up I must be, remember, what you love and desire will capture your thoughts and dreams. That dream was so real. I thought I could reach up and touch the character if I wanted.

Those kinds of dreams are what I am talking about. I told everyone the story about my dreams of my brother hitting me at the same time the ball hit me in the dream. Of course, all they did was just look at me. There you go. More evidence that your dream life is yours and yours alone. I did not mention the dream about the cartoon character till now. I knew that I would probably get laughed at or be called crazy. Most of the time people will not believe you when you tell them what happened in those type of dreams.

There is so much of life we enjoy through our thoughts and dreams, so why let it go? You harm no one, and besides, you can use the reward of the events to boost your current obligations. When you are down or slightly depressed, have you thought about what it would take to resolve the feeling? And when you do think of a solution, what happens? That is right! You smile and relax. Think about the times after you have daydreamed something that was pleasant. You also catch yourself smiling. Maybe someone else sees you smiling, and they say, "What's so funny?" or "What are you smiling about?" You know it had to be a good thought that made you smile. Our minds are so busy keeping us sane and alert to our obligations, it is nice when it treats us to a little satisfaction.

Then there are the unavoidable negative, horror, or scary dreams that visit us. I cannot tell you why they come. If I were to guess or match them with the cause, I would guess that those dreams come when you are afraid, caused fear, or avoiding fear. I would also wager that if those reasons are the case, the answer to those dreams lie in your life or your mind.

Of all the negative dreams I experienced, there was one that was unavoidable and reoccurring. That dream haunted and frightened me for a long time. It scared me so much that I tried to wake up or just make a noise hoping that Mary would shake me and wake me up.

The dream started out with me in bed laying on my back. I was asleep until something dropped from the ceiling and landed on my chest. It was a monstrous figure, hideous and with eyes like a snake. It stared me right in my eyes, and I was immediately paralyzed. I wanted to push it off me but could not move, tried to talk

but could not—nothing would work. All I could do was to make a slight screeching noise.

It was the type of noise that you could only make with your mouth gagged. I was helpless in every way imaginable to move, talk, or wake up. The monster had me completely covered and pinned down, but its weight was not the issue; it was the stare. The more I fought to wake up, the more I failed. The dream gave me real-life headaches while trying to escape.

The odd thing about the dream was that there were people parading by me in my bed and observing the situation. I knew all of them. They would lean over the bed and look at me and shake their head and move on without offering any help. That was very discouraging for me given the situation I was in. It made me feel like I was going to be like that forever.

The only way that I could escape the dream was if Mary woke me up after hearing me making noise, or I was eventually able to think hard enough about waking up. It was then and only then that somehow the dream would end. It was terrible. There were a couple times that Mary did wake me up and say, "Ed, wake up! You're dreaming." Then she would go back to sleep, but I was so happy she woke me up.

Until now that dream was never shared, not even with Mary. I guess that the dream was a way of saying that I was on the wrong road. I am not really sure of why the dream happened, but I knew it was telling me something, and I was not sure what it was. At that time, I was confused as to why all those lovely and innocent dreams had become less, and now I was being tortured. To top it all off, I thought that I had learned how to influence my dreams, so where did this one come from and why so many times?

7

More about Family

Being the oldest male, as you read, a lot was required of me as I got older. Soon Mike, the next oldest male, would earn some of the duties, and between the two of us we had to bring in the coal for the warm morning stoves and the fire grates. We also had to keep them stoked and take out the ashes. This would happen each winter. I can still remember the sulfur smell that came from the burning coals. Since the next two children were boys, Gene and Connie, as they got older the work was once again got divided up accordingly. It was then that my dad started referring to us as the four boys. He would come to the top of the stairs and yell, "Four boys, get your coats on!" It did not take long for us to understand that when we heard that term, it meant there's work to be done.

For the family, my father's television and radio repair business was an immediate way of getting quick money for some of the necessary things for the home. When he came home at night or on weekends after camp cars, I would work with him in his repair shop. I would also join him on repairs at people's homes. Sometimes the four boys would go, but we had to sit in the car while he worked. We would sit in the car sometimes for over an hour. While working with him at home in the evenings, we sometimes joked a little as we talked about television shows. That was nice. I usually didn't see him joke about anything unless we had company.

Eventually I was able to pick up enough knowledge to do some television or radio repairs in the shop or on the road during the week. What I earned as a television and radio repairman I gave to my mother. She would give me a dollar or two from time to time. I really did not expect that, but it was nice to have.

Sometimes on the weekends my dad would take the four boys out to the coal preparation plant. Each of us would get a bucket or two to pick up the coal that was spilled from the train cars as they went in and out of the preparation plant. Once the buckets were full, we would walk back to the truck and dump them into the truck bed. We did this until the truck was full. Sometimes we would fill the truck so full, the tires would rub the inside of the fenders. We would repeat filing the truck with coal and taking it home until our coal bin was full. That would mean at least two trips to the tracks, sometimes three. By now, there were a lot of requests from our parents that fell under the male role. I tell you all these things because each day my bank of memories grew and grew and set the stage for more dreams.

In our hometown there were two annual events that I remember everyone longed for. Those events were the County Fair and the Coal Festival. Though the Coal Festival came along in later years, the County Fair was always there while we were growing up.

Of course, early on the fair was off-limits to us for religious reasons, or so we were told. Personally, I think mainly the fair was off-limits for us because we had no money to spare. Can you imagine how tough it was for us to hear the sounds from the rides and pay-to-win booths from our house and not being able to see the action? Our friends would talk about the events like horse racing, automobile daredevils, and of course the food and rides. Later in life we got the chance to enjoy the fair and the excitement everyone talked about.

The coal company I worked for was instrumental in bringing what was called the Coal Festival. We were now at a point in life that we could enjoy the Coal Festival. There were exhibits like that were seen during the fair, but the main theme of the festival brought heavy mining equipment and other coal relics. The food stands, art exhibits, and games were plentiful as well. Uptown and all the way to the fairgrounds, there were show stages. Entertainers as far away

as from New York came to perform, and dancing and songs rang out from both ends of town. There was the big parade on Saturday and the nationality parade on Sunday.

The battle of the bands on Saturday was a huge drawing card. The festival committee had an airplane do a crowd estimation, and the Saturday uptown attendance was reported at a record-breaking number each year, with the report coming back in the thousands. Though the participation of the people from the city and surrounding area was good, the festival era slowly concluded.

That job that I took when I was thirteen was working at one of the town's funeral homes. I would also eventually put in time at the town's second funeral home. Most of what I earned from working I gave to my mother to help at home. All I needed was a little school lunch money and enough to buy pop occasionally. At that time, I could buy a bottle of pop, a candy bar, and potato chips for a quarter. Since my dad was known everywhere, one of his friends offered me a job at a filling station. That was also a fun job, and I met and made a lot of new friends. Some of them were adults. What was nice was when my classmates pulled into the station with their parents or other students, we joked a lot and talked while I fueled their cars.

I worked there for about a year. The part I dreaded most was walking to work and back, because I did not have my driver's license yet. By the way, back then gasoline was $.27 and $.29 cents a gallon, depending on which octane you bought. There were no self-service stations, and the pump attendants back then filled the tanks, checked the oil, and cleaned the windshields.

Once I graduated from high school, the country was involved in the Vietnam War, and everyone who did not have a student deferment for college was being drafted. I had two family friends who were officers in the local army reserve unit, and because of my obligations to my family, they suggested that I looked into joining. I joined the army unit in late 1969 and did both my basic training and advance individual training (AIT) at Fort Polk, Louisiana. Three of my brothers eventually joined the same unit. A couple went on to enlist in active duty.

With my brothers joining the unit, it made it a little nicer for me as the unit did not have any Black soldiers until I joined. The weekend service meetings at the unit and the two weeks away to active duty each year seemed a little too much at times. However, the alternative was a lot worse. Just for the record, I did not join the reserves to avoid active duty or Vietnam. I joined the reserves because we were living in the country, and I was the only one in the family that could drive at the time. With my dad away through the week, someone had to be able to provide family transportation.

Before entering the army reserves, I was working in a grocery store delivering groceries and stocking shelves. This job was one of the best in my early life. It also was a social type of assignment for me, and the friends started to pile up! Delivering the groceries was also fun because I got to drive a new van. The other employees were mostly family-related workers, and we got along well. Sometimes the store owner would let his grandchildren ride along as the deliveries were made, and we would sing as I drove. We would have a good time. The owner and all his family were good people. To this day, the family members are still as friendly as back then.

Later while still living at home, I landed a blue-collar job which was very interesting and educational. I worked there for about two years. It was there I got a taste of work that was not labor-orientated. However, while working there I still applied at several places where I could move into a job that had administrative and/or supervisory responsibilities. There were not a lot of jobs available for anyone who did not have some college education, so I did what I thought was the most logical thing to do. I enrolled in a state university branch and took some entry-level classes. I overloaded myself by working five days a week and going to classes five nights a week.

The worst part was a forty-minute commute to work, and after work add an additional thirty-minute drive to school. I did not get home until about ten or eleven o'clock each night. I would sleep, get up at six o'clock, and start over. Give that a try for about six months. Also, this was the time when I was with Mary and Michael. We had already moved in together.

8

❖❖❖❖❖

What Dreams Inspired

While falling to sleep one evening, I dreamed of working for a company that would provide me with the opportunity to have production responsibilities. The job would also allow me to dress casually and would provide structured hours that would lead to a good family life. I began to research and apply to leads in the paper, as well as word-of-mouth recommendations.

It so happened that the local coal company was hiring for an office position, so at the earliest opportunity I went and completed an application. It was not long I was called to go to work there as a clerk in a large repair facility. The job consisted of collecting and completing timecards for payroll, ordering parts for the equipment, along with answering the telephone and radio calls from the field. The relationship with the men in the shop was good, but my supervisor was the best! The man did everything for me. If I needed time off, he didn't hesitate to say "Take all the time you need." He was constantly advocating at the headquarters for wage increases for me and was super nice to my family. Even today I use his radio call numbers in my e-mail address.

At that time, I had a cousin working across the street, and he and I were the only Blacks in the company's office area. It was a while before he knew I was working there, because I seldom went to the main office. When he did find out, he contacted me. He had a beautiful 1963 Chevy Impala. He kept it very clean and drove it like

an older responsible adult. He was also taking college classes while working. From what I knew, he has become very successful with his life.

The job at the repair shop was a good match for me in a lot of ways. I got the opportunity to fill in for the shop foreman while he was off work and was given the opportunity to study while at work. Not a lot of time, but between my duties and at lunch. To say the least, I liked that. I think I did well there, and even though the pay was not that great for a person with a family, it gave me a lot of experience. I had the good fortune of eventually being promoted three times to better jobs.

Each of the jobs came after I watched and talked with higher-ups as they would come and go from the shop. I would go home and think of their positions with the company and later dream of how good it would be to have a like position. Though none of the jobs came immediately, as time went by better jobs began to become available. Once I learned what the job consisted of, I studied to learn what certifications and skills were required from the company, state, and even at the federal level.

While still working for the same company, I accepted a job with higher pay. The job was operating heavy equipment, and I started on afternoon shift and was trained for two days on the equipment and its abilities.

Though I hated the shift, I did not mind the work and loved the pay. Running the equipment to build roads and parks took me to different locations and other interesting projects. The company would often call and tell me to report to whatever location my equipment was shipped to. Two of my favorite projects included being part of laying ground for a large local park with camping grounds that were equipped for campers, and the other working at a neighboring county's airport with camping grounds. At that time, I was operating a TS-24 and a 657B pan, and we formed all the areas where the landing strips and the camper spots would be. That position also lasted two years, and I began hoping and dreaming for yet another role in the industry, and I never lost sight of my goals of supervising management.

The first of two more jobs came in the form of a maintenance supervisor. That job, too, pleased me, and our family began to experience a lot more things that we could not have experienced financially, and yes, socially. The second of those jobs was that of a production supervisor. All totaled, I stayed with the coal company for twelve years. Over those years I got a lot of training in management, human resources, equipment, maintenance, and conflict resolution.

The training I received came with weekly flights to Illinois to study equipment and trips to Pittsburg to study personnel management and other business classes. Some of the trainings lasted a few days, and other trainings required a couple continuous weeks. The training was part-intent, part-fun but was always worth the time. As a reminder, just as in making dreams, in life you must put something in to get something out. No deposit on your part gets you nothing in return.

As time with the coal company went by, I became friends with a lot of the other company officers and superintendents. Home life and lifestyle continued to favorably elevate. I experienced so much with the company, and I banked a lot of good memories along the way. While dreaming I saw a lot of possibilities ahead; after all, look at what my dreams had already shown and pushed me toward.

I have always thought of myself as a doer more than a dreamer, but I have long learned that my dreams had motivated and improved my direction. Though we see people working in the jobs that we desire, when it comes to moving ahead and fulfilling your ambitions, you need to keep your finger on the good-mind-set button and ready to push it when the opportunity knocks.

People also were continually influencing me throughout my life, but all that I have become professionally began with the things my parents instilled in me. It was my dad who first said to me, "You have to put money into a business to get money out." Through motivation and of course actions, I gained what I had dreamed of. As I mentioned earlier, dreams are not always happy, inspirational, or even disconcerting. They come in different colored packages and content, just like at Christmas.

The sum of a good or bad dream is often determined and seen in one's actions. So how do you earn good dreams with good outcomes? I say the answer is found by striving to live a positive life. It is not a necessity to become known favorably or always experience upward mobility at work to have a wonderful life. We have all had those supervisors who were not a bit pleasant or friendly. It was clear that their goals interfered with their ability to be socially correct.

Most of us will leave this world after achieving the one important dream of a lifetime. If that is you, I applaud you. Never forget the process of a *temporary yielding of direction* because that is where the action lies.

9

Unforgettable, Unforgivable Times

My life at home was just where I wanted it to be, but I failed to put the attention into our personal lives that was due. We did, however, go out some. We would party with friends, and none of that helped either of us. In fact, that became part of our downfall. At this time, we now had two boys, and my mother-in-law and my sisters did the babysitting for us. Through it all, Mary's mothering skills did not waver. They still were the best I had ever seen. I enjoyed the time when we were together, but I still liked playing cards and hanging out. Not good!

Mary holding Michael and Eddie

As far as immediate family and in-laws, things seemed good. In the beginning Mary not only spent time at her parents' house but spent time with my parents as well. While I was at the pool hall, she and the kids did things with both of our parents. We did enjoy and celebrate the holidays together, and we bought and exchanged gifts for everyone. The boys also continued to visit the grandparents during the holidays, and the relationship there grew. However, the product of all that I hoped and dreamed for was slowly dissolving, but I was too blind to see it. I continued going out. Sometimes I would not get home until it was about time to get ready for work. But you know, dinner was always waiting, and the family was always ready for some attention.

On those days when I was home in the evenings, I would lay on the couch, and the boys would sit behind me and on top of me while we watched our evening television lineup. The programs included *Sanford and Son, Good Times, The Jeffersons, What's Happening, Maude*, a host of Norman Lear's productions. On Saturdays, I especially tried to be home in the evenings because the program lineup was very good. We kicked the evening off with our favorite show— *Soul Train*. Then we would look for and select one of the Saturday night movies.

Sometimes we would play games while we watched television. The kids liked Yahtzee and most other board games or coloring, but their most favorite thing was having their mother read them a story or two. We would play and laugh until their mother put them to bed. That only left about an hour for us to sit together. I will never forgive myself for not putting the time into our relationship back then. My actions would create and cause us some rough patches and later division.

On top of my antics uptown, I played softball for a couple of different teams, and that occupied a lot of my time on the weekends. It was while playing softball we got the idea to form a women's softball team and join a local women's league. This was a joint idea, and the team we had from the beginning till the end was very good.

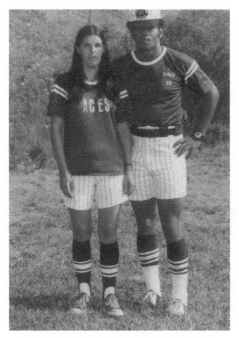

Mary and I at Softball game

We took some lumps the first season, but we learned from the experience and improved. We also drew the attention of a lot of good players who wanted to play for us. Some of the talents that came to us were college players looking for something to do in the off-season. Combined with the talented players we already had, the college players helped us to build a real dynasty. We played several unbeaten seasons. Mary would keep score for the team after she decided to not pitch, and she was thorough at it. She also designed the uniforms, called the players, and kept them in line and managed the scheduling.

We eventually got a team sponsor. It was a businessman who dealt with the coal company where I worked. He was super-generous with providing all that we needed; after all, he was getting the credit for how we looked and performed. He even attended our important games and was very serious about winning. He also provided for several victory parties over the years. After nine years in the league, we took a three-year break and then came back to play. We played four more years and concluded our history with a ninety-three and

thirteen overall record. I think working together in the softball days kept us not only busy, but busy together.

Practice and games were plentiful, but the cracks in the schedule gave me the opportunity to play cards. I knew that all of this was getting Mary upset, but I longed for the chance to play cards. The more I went out, the more I got the silent treatment. The hand was writing on the wall, and like the Bible's King Belshazzar, I had drank from the wrong cup and I was in for a rude awakening.

I remember being called to the door after work one morning and being greeted by a deputy. He handed me a petition for divorce and left. I asked her what it was about; she just turned and walked away. I already knew the answer. Though the authorities let us work out when I would leave the house, she wanted me out immediately. I went to my mother's house and stayed for a few days. I was hoping that she would call me and ask me to return, but she did not. It was a little difficult sitting at my mother's house and watching her and the boys drive up the road to what was once our home.

Eventually I left my mother's house. Not only did I leave her house, but I also left the city. I went to a small, very small place where a handful of houses represented a onetime settlement. I continued to work and pay child support. Occasionally the boys would come over for the weekend. Sometimes they would bring a friend. Those times were nice. After a little over a year, I once again moved. I moved back to my hometown and into an apartment. Sometimes I would have a friend over, but that was limited to the weekends or my days off.

10

Death Comes Calling

Around the time we split up, death took the family's greatest treasure. My father passed away. I remember I was out of town when it happened, and the news devastated me. To me, my dad was strong, smart, and the epitome of what a father figure should represent.

What happened was that he came home from work on the railroad and showered. Then he took my brother Paul with him to go on a television repair call. They were very fortunate that they made it to the home where the repair call came from. It was about a twenty-five-minute drive. They parked the car, walked up to the door, and when the door opened, he stepped inside the house, and that was as far as he made it. My brother Paul told us that the last words that he spoke while driving and before collapsing were "The sun sure is bright today."

I needed to get back home in a hurry, and a very good friend of the family made it possible for me to get home in a matter of a few hours. The day of the funeral services had us all numb. We had seen other relatives die, but never anyone of our immediate household. My mother was the biggest wreck of all of us. My older sisters tried to console here, but there were no words or actions that came close. At this time, my five older sisters were married and raising their own children. That made the evening so draining for everyone. My

mother could not help with anyone, and my sisters were busy trying to take care of their kids and all the siblings left at home.

With my dad's solid reputation throughout the area, there were lots of visitors, calls, and cards. His religious beliefs made him a gentle giant in the circles he traveled in. Though lots of condolences, nothing said or done put a dent in the knowledge that our father would never be with us again.

A few days after the funeral, my mother said that she was going to call his doctor and see if there was any information that would help us to understand why he died. When she told him that my dad died unsuspectedly while at a television customer's home, he said, "What? I told him he needed to retire! His health was such that he should not be working anymore." That really was shocking to learn. We all pondered why he did not tell anyone that and why he insisted on working. We also learned from the medical report that he died because of an aneurism bleed.

Death had dealt a terrible blow to our household, and as big as our family was, we all knew this would not be the last time we would grieve from death. True to form, a few short years later, death was back at the door.

11

---·◆◆◆◆◆·---

Digging In Alone

A fter my move, I had finally let go of any idea of reconcilia-
tion and concentrated more on work and new friends. Mary
and the kids were now attending church where there was a
Christian minister and congregation. She was invited to attend by
my sister Hope who was a member there. The congregation at the
church were very welcoming and went out of their way to make sure
they greeted as many people as possible every week. Mary and the
boys were very happy with the church and all their new friends. The
pastor of the church did lots of things with both the kids and the
adults. He took the kids fishing, skating and provided lots of game
nights in the church's social hall. My sister told me I should start
attending, so I did. At the time of my attending there, there were
revivals, concerts, and other programs with outside groups and sister
churches. I soon began to enjoy the fellowship.

It was so different attending this church compared to where
we once attended services as a kid. On Sundays there were Sunday
school classes followed by church services and then Sunday evening
services. On Sundays I would see my wife and kids in services, but
she and I did not talk. The boys always spoke. They made so many
new friends that they hardly noticed us once they went to their
classes. On Wednesday night we had Bible study upstairs, while the
youth of the church met downstairs. About fifteen minutes prior
to the Wednesday night services concluding, the younger kids came

upstairs and were provided a devotion by the minister, which some-times included games. There was also a music portion to the closing. There were so many kids downstairs that when we were dismissed, the doors to the front of the church flew open and fifty to sixty kids stampeded to the vans. That was a very nice scene.

Another nice thing about attending the church was that there was a church softball team. Every Sunday there would be two ball games at the church camp. The boys would go sometimes, and they would swim or just run around with friends. One of my brothers attended Sunday services so that he could join the team. It was a requirement that you had to attend services if you wanted to be on the team. Our team was very good, and we too went some seasons undefeated. It was so nice on those Sundays, but we had to hurry back home so that we can get ready for evening services.

I was working midnight shift at the coal company as the main-tenance supervisor. Time dragged along, and I never really adjusted to sleeping through the day. I also never thought about the respon-sibility of cleaning house, washing dishes, and preparing meals and lunches. Should friends stop by, I tried to make sure that the house was clean and there was something to offer them. When the oppor-tunity to go out socially came around, I tried to be available. When the boys came to my home, I kind of rolled out the red carpet for them. The church events were still a great drawing card for them, and I sometimes took them and watched them enjoying the evening.

At work my dream of taking another step upward came to pass in the form of a production supervisor's position. That meant working three shifts, working with different crews on different shifts, while trying to joggle a schedule that included the boys. As far as the new work assignment, I was feeling it. It was good to report on the work completed on the shifts to see how much coal was uncov-ered and how much made it to the preparation plant. The men were more than willing to meet our targeted expectation in tonnage for the shift, and we worked out ways of rewarding their efforts in a quick-return method.

I recall that the chief officer of the company even made pos-itive comments on how our crews worked and produced. I could

see how all the training I received played a role in what we planned and accomplished. I found out that the effort I put into learning returned a favorable production record for the company. Well, at least for about two years. In the meantime, I had purchased a home and moved once again.

12

Changing Lanes

Sometimes good things come to an end. When that happens, it is time to look for something that is just as rewarding and hopefully something that you want to be involved in. If you are lucky enough, you may land a spot in the same industry—a place where you can apply all the knowledge you acquired at your previous job. I asked myself, "What has your dreams and desires told you?"

The coal industry was taking a hit from the environmental protection agency, and a lot of companies and mines were shutting down. Of course, the trend reached our company, and I was laid off. To top things off, my wife and I had reconciled. We were remarried in the church we were attending. It was a small service with basically our family and the minister's family. I was happy about getting back together, and I knew job security was paramount in my decision making. I knew that they all were concerned about our future, and I told them not to worry, I would find another job.

After taking some time off, I responded to an ad for an entry-level position in the health-care industry. I do not know why, but I did. I guess I was thinking at the time that I needed to get back to work for the family's sake. It so happened that the position I accepted required direct intervention and teaching the residents, based on annual plans. The individual plan was developed by a strong team of professionals, and deviation from the plan would be counterproductive to the individual's expected progress. Well, there I was. I

thought, *Should I stay with the job? Is this what I wanted to be doing moving forward?* While I was working there, I was being inundated with training on how to improve on people's lives, while making them understand the importance of the training.

About six months into the job, and while sleeping one night, a dream hit me like a ton of bricks. I saw myself moving into a supervisory position. So I went to work learning everything about the industry. I got on every possible work improvement committee I could get on and went to work knowing just who I need to know in both the industry and the company. I distinctively remember a vice president coming to our region and speaking about our goals. I was so impressed with his words, his deminer, his knowledge, and of course the way he dressed. That did it. I said to myself that I will get a better position with the company. It was not long after when a management position did open. I was interviewed and was awarded the position. I was on my way!

Just as everything seemed to be coming together, death knocked again. This time it was one of my younger sisters, Ora. As far back as I could remember, she had heart problems of which she had several surgeries for. At one point, Hope and I took her to a university hospital for a final surgery. Following the surgery, we were told that all had went well, and if she followed the instructions given her, she would be fine. Regardless of what all went on, she died while being pregnant with twins. The days surrounding this event were even harder to bear than it was with my dad's death. So young and lots of promising things on the horizon.

Ora's death also had mainly caused my sisters to be the most upset. There is a saying that indicates that girls, or sisters, don't get along; I know that is true, but no one rallies more with support than when sisters need each other. All is put aside, and they run to comfort or assist in any way possible. During Ora's death, the girls were back together at our parents' home comforting my mother and pulling the family together. They were trying to comfort as much as possible. That included Mary with our Amy.

In time a new regional position was developed. The position would be that of an assistant to the regional director. I was offered the

job. This was an especially exciting time in my life and for my family. We now were a family of five, and with our daughter Amy's arrival, it was even more of an exciting time in so many ways.

There was something new to be learned every time a regulatory group performed a survey. Sometimes the results of the survey required that the rules of operation be changed. When the company had to adapt to the changes, the staff had to be retrained. I often got involved with the training because I enjoyed the opportunity to see other operations within our region. Sometimes I visited to the corporate office during company-wide regional meetings. Looking around the meeting room at the executives and regional directors, I got the overwhelming feeling of "This is it, write me down for that." I can remember distinctively that I was talking with a regional director from Washington, DC, and I said to him, "Look at all the clout in this room, I am going to know everyone here before I leave!"

For the next six months or so, I once again studied the responsibilities connected with the company's mission. I studied the governing guidelines and wrote policies according to the requirements. The policies were shared in the future meetings, and most were adopted. There also came a time, while preparing for a regulatory audit, that I developed a form that summarized required content of our program delivery. That form was designed to interface with the regulatory process without the need of extensive past and present record review. That form became a popular audit time-saving tool with our auditors.

The work I performed was intensive and ever-flowing. Though I received hours and hours of training so far in my career, I still realized that more education was needed. Most of my peers at the time held bachelors, master's, and some doctorate degrees. They came from different backgrounds and industries. The one thing all of them had in common was the desire to succeed in the new field. So I went to work earning an associate degree in business management, and later a bachelor's degree in business administration.

One day when leaving a corporate meeting, the thoughts and dreams within my head were so intense that driving home from the meeting, I covered the two-hour trip without hardly remembering

the journey. I thought of sometime becoming a company officer with a greater responsibility. I wanted my own territory to manage. Our region had started to become one of the most evolving regions of the company. With new acquisitions and new construction, we would soon make the turn toward a thriving and more profitable entity.

The years with the new company got better and better as time went by. Over time I had got to know the chief executive officer, the chief financial officer, the company controller, the human resources officer, the company legal officers, and mostly everyone in the corporate office. I had already worked with and visited all of peers in the regions every chance I got, and the executives and our group became like a family doing business.

Within the region I was given the autonomy to build, promote, and select all the support staff and the area directors. There was a harmony within the region, and everyone was aware of the goals we intended to fulfill. The company followed a strict strategic plan, and our region had a plan that incorporated the company goals and a few of our own.

13

Rebuilding Our Life Together

At home things were better this time around. I worked hard to be more conscious of the family and their needs. School projects, church projects, and church outings and camps, and a long list of other family happenings burned a lot of downtime. We even resurrected the women's softball team for the finale that rounded out the ninety-three and thirteen records. The time went by fast, and we put four more years into managing the team. Softball was still happening at the church camp, and our team was still winning. However, the men's ball team involvement for me was history though.

Though everything I knew before seemed to have disintegrated, favorable adjustments were made as we moved on. Those who have been down this path before can relate to changing to keep your family. If you are fortunate enough to have a stable relationship through your marriage, hold on to it. If problems arise, I highly recommend finding a good church and attend regularly. I will have to say that joining the church was what made our relationship survive. We had both seen and lived both good and bad times over the years, and we are still here.

In time the three ballfields at the camp were eventually grassed over. The camp opened its doors to different events and nonchurch-related groups. The accommodation at the camp now includes a modern lodging facility that caters to couples and/or fam-

ilies. A lot of outside organizations held business-type meetings and team-building exercises. Some football teams spent time there and were preparing for their next season. The typical multi-resident camp dorms are still there, but remodeled, and the challenging obstacles at the wilderness camping area have also been modified. Of course, the swimming pool remains popular during the camping season. I guess opening the doors to other groups did help in supporting the camp from a business perspective.

Knowing that spending time away from home had separated us before, I did my best to be a model husband and father. Deep down inside, I knew that remaining as a family would take a lot from both of us. Not for one second did I imagine that taking this journey again would be easy for either of us. Attending all those family-related things did bring us closer this time around. With both of us working, we even had a deal where the first one home made the evening meal. That was okay though. I kind of liked to cook, even though back then I never told her so.

Over the next few years, we saw different pastors come and go at our church. Mary had now established relationships with a lot of the church officers and the membership. She was more sociable than I was at church, so new friends and some relatives sought to hang out with our family.

My sisters Hope and Regina also became very close with us. Mary also belonged to the women's organizations and attended their meetings and events. She became an officer in their organizations and did an excellent job in leading the group. Sometimes that left me with the kids, but I really did not mind. Those times when we called on my younger sisters or someone from the church to babysit continued if I had to work or referee a basketball game. When I was away to referee, during the drive back I felt good about heading home because I knew everyone would be there.

We very seldom spoke of the time we had spent apart. I think neither of us wanted to. Wanting and needing to be back together took precedence over what we had left behind. Getting ready for the kids' projects and events, along with all the other normal stuff, still seldom left time to sit down and talk. At bedtime, one of us

sometimes may have fallen asleep ahead of schedule, but there was no need to panic. As the new days all began to resemble each other, we took them in stride and enjoyed the time we had with the kids in the evenings.

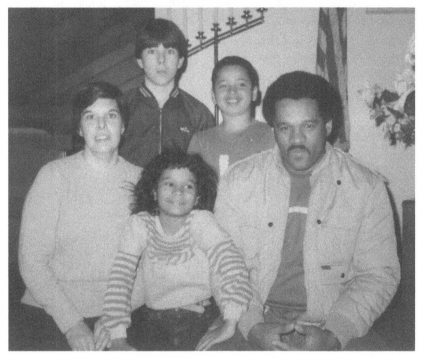

An early family photo taken at church

As the kids started to leave the nest, we spent a little time driving around, shopping, and planning what we would do once we both retired. Mary would repeatedly say how she could not wait till we were old enough to spend the evening sitting on the porch together. I did not see the value of that, but I was in. I am sure that she got that idea from her parents' life. I can remember seeing pictures of her parents sitting on the porch and holding kids, theirs and grandkids, of course.

The family at Eddie's wedding

Mary did not come from a small family either. She was the oldest of seven. Like my family, they had older girls that helped with the home duties. Mary was the oldest, and Ginny was the next child. In the total of seven, there were three girls and four boys. Later would come Avril (Flip Jr.), Cathy, Mark, Kevin, and Craig. They lived on a farm, and their father mainly raised goats and sheep. He was a coal miner by trade, but somehow managed to care for his farm and his animals. He, along with Mary, his wife, Ginny and her kids, and Kevin, eventually joined our church.

When I was younger, I remember going with my father to repair their television. I did not pay any attention to the kids or the surroundings, I was preoccupied with studying country living. I never imagined that in time I would be in the country and living just a few miles away from my future wife.

With all the kids in high school, the extracurricular activities were plentiful. With Michael in wrestling, Eddie in football, and

Amy in cheerleading and volleyball, running around to keep up with everything was a little tough. With me working different shifts, unfortunately a lot fell on Mary at the time. Listen, she never once complained. She would talk about some of the happenings, but honestly, it was before or after work and I, admittedly, was tired and did not pay attention most of the time.

14

＊＊◆◆◆＊＊

Mary

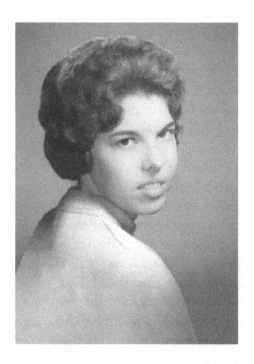

Meeting Mary for the first time was an exciting experience. At the time I was doing nothing to enrich my personal life, and it was just good to have someone to talk to. She felt the same way. Over the course of a couple of get-togethers, we found out that being with each other was something we both enjoyed.

Mary was a good student in high school, very intelligent and was involved in or a member of many academic clubs, outside organizations, and many other school activities and programs. She was a class officer, an *A-plus* student, and the class valedictorian. She never once bragged about her accomplishments or her education. When we would talk, she would sometimes surprise me with all she knew and had accomplished.

Once I was working on a school project for my associates degree and I misspelled a word. I gave her the assignment to review. She read it over, and instead of saying, "You misspelled a word," she handed it back to me. A little while later, and not in a demeaning way, she said, "Hey, check that word *tentative*. I think it has two t's in it." I just looked at her and smiled. She did not see the smile because she was reading. That is just the kind of person she was at home. People, I never (as you can tell) forgot that!

As far as her life prior to us meeting, I can recall bits and pieces of seeing her around but had no reason to really commit the occasions to memory. I do, however, distinctively remember seeing her in a car with a friend, and I knew that she worked at the high school. Those times my dad and I were at her house to repair the television, we both were in grade or middle school. I also remember her working in a restaurant while she was in college. On one occasion I was in the restaurant and ordered a coffee while she was working, but that occasion was also not significant at the time.

Besides going to parties at our friends' homes, we went to a lot of movies and drive-in theaters back then. The first movie we ever saw together was *The Sterile Cuckoo* with Liza Minnelli and Wendall Burton. That was in 1969. Following that movie, we continued our moviegoing about every week, and the movie titles grew. We kind of liked the drive-in theaters a little more because we could sit close, hold hands, and lean on each other. The drive-ins also brought the excitement of watching other moviegoers as they sit on the top of their cars, sit in the back of their trucks, drive away with the speaker still attached to the window, or being tossed out after they were caught trying to sneak their way into the movie.

Mary and I on our third date at my parent's house

Another thing she was attracted to was going to my house and visiting with my parents. We were still living in the country at the time, and it was then that I surmised that we had the same family values. As time went along for us, that surmise proved very true. To me, going home to my house and witnessing all the noise and confusion would probably chase someone away, but she loved it. Afterall, at that time there were still fifteen of us still living at home. Instead, very casually, she played it off.

When we were out with friends, Mary would tell our friends about what she experienced or observed while at our home. Her number one experience that she told was about asking my mother if she could help her with preparing the evening meal. My mother answered her and said, "Sure, you can peel the potatoes." With that being said, my mother picked up a ten-pound bag of potatoes and put them on the table. She then reached in a drawer and retrieved a butcher's knife and handed it to Mary. When my mother handed her the twelve-inch knife, the look on Mary's face was priceless. Mary

then asked my mother how many of the potatoes should she peel. To that, my mother replied, "All of them." Now, if you think that Mary's facial expression was something in response to my mother's giving her a butcher's knife after being told to peel all ten pounds of the potatoes, getting the knife fell to second place!

I was always a lover of cherry pie. One day Mary and my mother made pies, and she told her about my wanting cherry pies all the time. Of course, every time Mary was in the baking mood, it was cherry pies that she made. She made so many, I lost the taste for them. Then she started making apple pies, and my love for pies took a turn. Other things that she made were homemade noodles, cabbage and macaroni, red potatoes with chicken and green beans, and the list goes on. When we had meals at the church, she made scotcheroos for dessert. I am not going into all the details about the scotcheroos, but let me tell you this: She got requests for them all the time. When she made them for the church bake sale, they went fast.

Her second favorite story to tell was about those shopping and going out to eat with my parents. Today I still ask myself why I did not go with them. One possible reason was that I really did not like going shopping. I know that I was not the only guy that felt that way. Even today I do not know any guy who would say I like to go shopping with my wife. Do you? Secondly, I do not think she wanted me to go. Sometimes she really enjoyed time with them by herself. She would talk about the experiences for days or till the next time they went out. She told me that my dad would carry Michael around the store, and the people would stare at them. Imagine that.

The apartment Mary and Michael lived in when we met was a tiny second-floor place. There was a combination of the living room and kitchen and a bedroom. She did not mind the apartment size, nor did I. We were hardly there those first months together.

Back then the most common thing that newlyweds and young couples did was to buy or rent a mobile home, and we were no different. We decided that the ones that we saw around town were too small to invest in, and when we called the different mobile home lots, we were told that the new thing coming out on the market was a seventy-by-fourteen home. The hitch to purchasing the bigger home

was that there were not a lot available at the time. We finally hooked up with a company in Parkersburg, West Virginia.

The salesperson we talked to described some of the homes he had built for other customers, and he invited us to come to Parkersburg to design our own home and we went. Most of what we decided to design was done by Mary. I could tell she had thought about a home someday, and she was putting that design in our first home. I did not mind at all.

Once our home was built and delivered, it was then that Mary began directing the workforce; I and Michael, that is. Since Michael was still so young, guess who the *warden* called on. Through the week I was still working away and going to school, so I escaped some things, but the warden let me do them on the weekends. I was happy, and it looked like I had fulfilled most of my dreams about having a family with a wife like my mother. The movies and visits with friends still happened, but not so often. Those months together were magnificent and, to date, were the best times of our lives. To top it all, things seemed to always work out for us. Wish we have never lost those days. They were the best for our relationship. Why did they end?

Another couple of years went by, and after negotiating some rough waters and staying together, we decided to buy some land of our own to put our home on. I was friends with a sitting judge at the time, and he owned some property that was just sitting unmaintained. One day I went to his house to see if there was a possibility we could move our home to the site. He was one of the best men that I personally knew. He asked me what my plans were for the future in terms of housing. I told him that we did not really have any plans in that area. Anyway, he proposed that we purchase the property on a land contract, and he would draw up the deal. I could not believe my ears. Of course, I agreed, and again dreams from my youth took form and flew. Soon as I told Mary she said, "Get us some boxes." We had the land cleaned and leveled the way we wanted and made the move. We were now paying for our own home and our own land. In case you did not catch it, the keyword used there was *our*. We both liked that.

At this time, I was working at the coal company in my first assignment. Things were tough, but we survived. I picked up a part-time job, and what I got from the army reserves helped with our living expenses. I did not want Mary to work, mainly because my mother did not work. I am sure she did not mind staying home with Michael, and her sisters visited regularly.

One of the things that I really loved about Mary was that she was an impeccable housekeeper. That was another thing that made her like my mother. For what we had, my mother demanded cleanliness and organization. I know you are not supposed to mention those kinds of things, but I could not wait to get home and walk through the door. The house looked good, the air was always fresh, and the smell of food cooking or warming had me delighted. I think you get the picture.

I felt as my dad did when he got home. I now knew how he must have felt when he opened the door. It was about then that the good old dreams were about to introduce the first of the three better jobs. It was the beginning of the times when money we needed was beginning to make everything else feel better.

Mary comes to the bedroom doorway with a style
show after a shopping trip. She did that often.

On our land there was lots of space. My brother Gene asked if he could put a mobile home on our property. I asked Mary if it was okay, and she agreed. Eventually, my brother Paul put a mobile home on the property as well.

Do you recall the saying that says something like, "Once things start going good, bad is somewhere waiting to derail you?" That is so true when you let your guard down and/or slide into complacency. Most of the time we are the ones that open the door that leads to problems, and once that door is open, your dreams turn into nightmares.

During that time when my dad died, when I got to my parents' house, Mary was there waiting for me. We did not speak of any bad things or any problems, nor did she ever leave my side through the funeral and the days after. She would even stay with me while I took a shower, and she prepared the clothes I was to wear. I could not think or communicate straight over that period, and I knew that I did not deserve the help that Mary was giving me. It was good but still felt somehow strange.

Surprised Mary with gifts after a business trip

During the days afterward, we spent a good bit of time together working on reconciliation, but we were not getting anywhere. We did not fight or anything, but she, more than I, was ready to give up. This was the time when I went to my mother's home for a while and eventually moved out of town.

I left everything behind while I was living away, and I hardly came back to the town during the week. That was also a time when I focused more on work, and over time the additional promotions came, and that made things a little worthwhile. By the time I moved back to the city, I was completely over the past. I did continue to go to church, and many participate in many of the events. I had a complete friend makeover during that time but continued to pour myself into my job. A second time of being single was not part of any of my dreams. I was now on strange ground with my social life, and eventually I am living on autopilot.

Very surprisingly, one day Mary called me and asked if I wanted to stop after work. I did and we talked some and spent the day and night together. The next day I went home, and I only saw her and the boys at church for about a month or so. Another time we were all at church together, Mary asked me if they could sit with me. That was nice, and people began asking if we had reconciled and when were we getting back together. I did not have or give an answer, but from that day on, Mary and I talked on the phone about our life together and how we got to where we were. I soon moved back in.

Mary, in the meantime, had started working. She liked to work and liked the people she worked with. She continued to work once we were back together. This was the time when we had to provide a babysitter for the kids, or she would take them to the pool where they stayed most of the day. She would use her lunchtime to bring them back home. If I was working a different shift, I would go get them when I woke up. Most of the time we had evenings together, and that was nice. She made sure that the kids got taken care of while working and spared no expense in getting them everything that they needed to be happy and taken care of during the day.

A different home and remarriage followed, and Amy became part of the family. Life was not great; it was grand! We experienced

everything you could think of as a family over the next few years, but this time when bad times tried to surface, we talked through it and stayed together. The jobs got better, the kids grew up, and we had turned our thoughts to those days of sitting on the porch once we got older.

Young Michael, Eddie, Amy

I put a lot of effort into providing Mary and the kids all that they wanted, and it was good to see them experiencing the lifestyle that their friends enjoyed, especially with their parents being together. My new job with the coal industry had me busy through the week, but thankfully I was mostly home on the weekends. Mary's parents had joined our church, and Mary and the kids spent a little more time with them on the farm. Her sister continued to visit regularly, and

she visited her at her home occasionally. Her mother and sister began coming to our house and would play scrabble or other board games. It was nice of them to visit.

Mary gives me a surprise Birthday party at work

All the kids graduated from school and in time left and started families. We got to see the grandkids and enjoyed watching them grow. Sometimes we babysat them. Mary made an all-out effort to have everyone home for Christmas and Thanksgiving. She would spend the day either preparing the meals or wrapping presents. We were a family, and it seemed that all my childhood dreams had come true. I would sit in my chair and look around the room as the packages were being opened, and I felt like my parents did when we were kids. It felt good! Over the next few years, our family grew. The good times and some bad times were still there, but not so often and not so dramatic. For a while we worshipped with the kids on Sundays, but in time they either moved away or stopped coming.

During those years I had retired and went back to work somewhere else three times. In between those times I was at home, I cooked, cleaned, did the laundry, and took grandbabies back and forth to school. In time, Mary retired and I was back to work. I started working toward what I thought would be my last attempt at

retiring, and we made plans to drive out West. We had no destination, but just to get on the highway and drive.

After Mary decided to retire, she took two trips that she called mini-vacations. She and a group of ladies had also scheduled an ocean cruise; however, that cruise was cancelled due to COVID-19. The first trip she got to experience was to go to Amish country with some ladies from the church. It was an opportunity for the group to just chill out and visit away from distractions. The second trip was a bus tour along the East Coast through Connecticut to Maine, with her two sisters Ginny and Cathy. She sure loved that trip. They had several stops at tour destinations, and she took a lot of pictures. But most important, she got to be with her sisters.

A family vacation trip to Chesapeake Island
with Mary's brother and a friend

It had been a while since Mary and I had taken a formal vacation. We had taken the family to the East Coast a couple of times. We camped once and stayed in a beach house with a lot of her family members. There were also periodic vacations for her and the kids

down South to visit her sister Ginny, but I was not able to attend. In addition, our son Eddie had booked two trips down South with his daughter, and we were invited. All the most recent trips were important and very timely for the saddest of reasons.

About eighteen months ago, Mary complained of backaches, which were seriously painful. She was seeing her physician for the pain and was prescribed pain medicine. It got to the point that the pain complicated standing, walking, and even sitting. She could not sleep. Any position that she found a little comfort in eventually brought pain. We bought her a chair with remote positioning. That did give some relief, and she started sleeping in the reclined position or any position that would reduce some of the pain.

She developed a problem with her bladder, so we took her to a doctor where a lot of tests were ordered. We were called back to the hospital, and the doctor said he wanted to operate and insert a stint to relieve the pressure from the kidneys and the bladder. The operation was performed, and when he returned to the family consultation area, we were told that she had cancer. He told us that the cancer was pretty much spread throughout her bladder and kidneys.

The surgeon then had us consult with an oncologist. We did, and he also ran some tests. From there chemotherapy was started. About a month into chemo, the doctor also ordered dialysis three times a week. I really felt bad. Two or three days in dialysis, and the other days in chemo. It was taking a toll on her. On top of that, we were taking her back and forth to the hospital where she would stay for a few days when she was having a bad time, or there were other problems.

You know, on those days when she was home, I would see that she was comfortable and had what she needed as she relaxed and watched TV. It was not long that I would hear her walker being used as she would go to the kitchen. I was like "Mary, I will get you what you want." She just said, "I am okay." I had fashioned a carrier on her walker so she could carry things when she needed. In a little bit I heard the walker again. Of all things, I saw her heading my way. When she got to me, she reached in the carrier and pulled out a saucer with apples and cheese that she cut for a snack. That was her

favorite night snack. She was tired by then, so I helped her to her chair and I thanked her for the snack. During the times that she was home, she did that each night, until she could not.

It was just a few days, and Eddie and I had to take her back to the hospital. Each time that we went back to the hospital, the restrictions grew because of COVID-19. This time it was the worse. We had to leave her at the door with a nurse, with not even having the chance to say goodbye, so as soon as I got home, I called her. When it had been a couple days without seeing her, the doctors would sometimes take us in to see her.

One evening while she was in the hospital, I got a call about eleven thirty that pretty much asked, "If your wife has difficulty, do you want us to do everything we can to help save her?" I jumped out of the bed and said, "What?" The statement was repeated, and I said, "I am on my way down there, and I better be able to see her!" I called Eddie. He came and picked me up, and we went to the hospital. There was a security guard there, and he told us that we were expected and someone would be down to take us to her room.

When we got upstairs and to the room, she was not there. I asked where she was, and they told me she would be down shortly. When she was wheeled into the room, she looked very bad. I started to cry and could not stop. They told us she would probably sleep all night. I told them I was not leaving and that I would be there all night. I told Eddie to go home to his family and I would get a way home the next day. I held her hand and cried most of the night, while she slept through.

No one really told me anything of why the call was made to me that night. All I was told was that she had a hard time in dialysis. The next few weeks were even harder for her. Between all her treatments and traveling, it was to the place she could only get around in a wheelchair, and the transferring had her in tears from the pain. One evening the issues with her kidneys and bladder were so bad, we took her back to the hospital. It would be her last trip to the hospital.

The next day the oncologist called me and asked me to come to his office. Eddie drove me down, and we waited a few minutes in the conference room for him to join us. We did not say much, but

we both knew what was coming. When he got there, he told us that the treatments at this time were futile. He showed us everywhere the cancer had migrated to and said that the treatments she was receiving were somehow hindering any success. He then took us to see her, and he reiterated what he told us. Of all things to hear, Mary told him to stop wasting his and the hospital's time and she wanted to go home. Then she said, "Everything is going to be all right!"

When we got her home this time, we brought in a hospital bed and some other equipment that she would need for the time at home. Mary's sister Ginny had been with her all through the times when she was home from the hospital. Ginny was an absolute lifesaver. I had to work to keep the insurance, or I would have retired then. I was home as much as possible, but without Ginny, it would have been chaos for us. Mary wanted Ginny to be with her, not just because they were sisters, but because they were very close all through her life.

During Mary's last three days at home, Amy flew home from work to be with us. Eddie got off work, Michael came over, and a hospice nurse was also there for the last two days. I can remember remarking to the kids that this was the first time in years that the five of us had been in the house together in years. The kids sat with their mother for the last two days. At night it would be just Mary and me. In the mornings before work, I made what she wanted for breakfast, along with her coffee. I still do not know how Mary went through all of that and never ever showed or voiced pain. That made me recall that over fifty years earlier, she told me that through her entire life she had a high tolerance for pain. Remembering that did not help at all, but she was right.

Only once on the final day did she make or indicate pain, and that was because we moved her. On her final day, May 4, 2020, Mary and I talked as much as she could tolerate. The kids were in the living room, and I sat and held Mary's hand. She seemed fine, and she talked a lot. As the pain moved in, her voice was cracking and getting low. Her facial expression changed, and I could tell that something was happening. At the best she could manage, she told me some things, and toward the afternoon with our family all together, she left us.

15

The Value of Family

As I have shared these moments, let me say up front, the family time that I spoke of in my parents' house will never be forgotten. Good, bad, or indifferent, it was part of our life. We, my brothers and sister, experienced all that life offered and learned from all those experiences. We were spanked (they were called getting a beating back then) when deserved, sent to our rooms when deserved, made to apologize when needed, and in the process, never repeated that cause again. Well, at least not in front of our parents.

It is really a sad thing when you are speaking to someone and you ask them about their relatives, and they cannot tell you anything. Sometimes they cannot even tell you where they might be living. That kind of thing, I am sorry to say, is very common and widespread. However, I believe you cannot blame the younger folks. For years now, the popular thing for kids to do is to play video games, and nothing or no one can disturb them.

I am not getting on a high horse here now, because it was us who bought games for our kids. The games are violent now, and the product of kids being exposed to those games is being revealed just about every day. I do not have any answers, and I do not think anyone does. All I am saying is, being left alone to fill your mind with violence and other things is not helping to pull the family together. Even in our family, people move away and do not call or visit like they should. When I was a kid, our parents made sure we knew our

relatives. My mother's sisters came and visited her, and sometimes my dad took her to visit them. I got to know my grandparents and all my uncles and aunts. My cousins were always around, so I knew most of them.

When we began having family reunions, both of my parents had already passed. That was so telling of the communications and interactions in our families back then, besides reunions, were not that big then, at least not in our family. Now we encourage all our family extensions to come to our reunions, and they do not reply. We always say goodbye to everyone and remind them that it could be the last time some of us will meet, and that was so true. I had talked Mary into coming to our reunions, and she attended the last two before she died. COVID-19 made us cancel the 2020 reunion, or she would have been there. Who could have known that in nine months after that reunion date she would be gone?

Before my mother died, two more of our siblings passed. That meant we had lost four of us. After her death and over a period of a few years, seven more died. That left eight of us to date, three girls and five boys. We do communicate and try and spend some time together. With social media being what it is nowadays, that has become the quickest and easiest way to communicate. That is all right though. It counts as something that works toward family communication.

The stories we generate as a family are what stimulates our memory the most. Those stories that we revisit that causes us to smile happens even when we are alone. They are priceless! Reunions are famous for that type of thing. When you are together with family, do your kids, your siblings, or even your parents ever say, "Hey, do you remember?" Give yourself a pat on the back; you and your family had something. Those kind of stories and conversations can go on for hours.

Sometimes when Mary would come home after taking the kids shopping with her, she would give me the bad side of a day that started out good. One time she told me that they were entering a shopping mart, and she told the kids that if any of them were bad, she was going to spank them right in front of everyone. First, this was

a time when you spanked the kids for doing wrong, and you had no fear of children's services knocking at the door. I will not get into the politics of all that, but here is what happened. After telling them all of that, Eddie, who was about eleven at the time, said, "You might as well spank me now, because I am going to be bad!"

Thirteen of us siblings and our mother at my
brother Phillip's memorial service

We kind of expected Eddie to act out in situations like that because he learned early on to put things to the test. Michael and Amy were more of the fashion shoppers, and they did what their mother asked, just in case they saw something they liked and wanted. Regardless of how any of them acted in a store, Mary usually bought them anything they wanted anyway. There was also an infamous shopping story that happened with Michael. One day we all went to several stores to do some shopping. We shopped all day and into the evening because we had thrown school shopping in with the regular shopping. I knew that Mary had given each a dollar value on their

individual shopping desires, but they didn't hear her. I just tagged along and observed the way they all kind of knew what they wanted, and none of them brought a list. Interesting, to say the least. At the time Jordache jeans were both popular, fashionable, and of course expensive.

When we got home, the kids all disappeared to their rooms and started to try their clothes on. There was a small fashion show that took place with Eddie and Amy. I looked at Mary and said, "Where's Michael?" I went upstairs and looked in his room; he was not there. I checked the bathroom; he was not there. I asked Mary again, "Have you seen Michael?" She said no, and with that I started to the basement door to check down there. There he was sitting on the steps. I asked him what he was doing; he said nothing. It so happened he was sitting there with scissors and cutting out the knees of two pairs of seventy-dollar jeans his mother had just bought him. I just turned around, shut the door, and went back upstairs because I knew that open-knee jeans were also a fashion then.

As I have revisited the times and the journeys I took with my family, I could have no regret over anything that befell us, or me. Life and the time were what they are. Each family had their own lives to live and share, and that was what gave us diversity and made the world so resourceful.

I continually said that I would give anything to relive those days. But really, what would that accomplish or benefit? None of us had the ability to change anything; and furthermore, the outcomes then were what motivated us based on that period.

I have been fortunate enough to be given the opportunity to share the biggest part my life with you, and I would appreciate your willingness to read my story. There is so much that goes and goes with the years you spend on this earth and taking the time to enjoy that is what builds the memories.

My wish for all of you is that your life be as interesting as mine. I also hope that you will be able to build your own story from the pieces just as I have.

We know that the longevity of life is uncertain nor predictable, and that if you live your life as prescribed and inspired by Christ, there will be a bigger reunion someday.

Since the days of my youth, our children have all experienced growth in their own families, and the grand and great-grandchildren numbers continued to grow. The same had happened with all the members of the Banks family.

We are not special, or do we brag of any special contributions to society. We brag that we were able to be part of society.

We will continue to have reunions and communicate with each other. We encourage you to do the same.

I will leave you with these final thoughts: With the troubles in our country today, remember that on one person, nor one party, can control all the people or the parties. If we can't resolve our differences peacefully and immaculately, we are doomed as the human race.

Also remember that life is short, and that there is a storm with biblical ramifications and proportions brewing. That storm will one day end all life on earth as we know it. So please get to know God through the teachings of his son, Christ.

Fishing Days

Alas, across the deep blue sea I see a shining light,
Bring her about, the captain shouts, 'cause we're going home tonight.
Fourteen days and thirteen long nights, we have sailed this deep blue sea,
With net in hand, no sign of land, we have fished to earn our fee.

Yes, it's home at last, I can see it now, we are coming through the bay,
Look alive, no time to strive, for tonight we embrace our pay.
No more days of drifting wild and shielding wind so bold,
Lower the sail, ring the bell, we have got stories to be told.

Tonight, there will be no wind or rain, nor lightening around our head,
We will be sleeping dry, not seeing sky, after nightly prayers are said.
We will happily see our loved ones…wife, baby, and son,
We will dance and sing, gifts maybe bring, till the celebration is done.

There is nothing like being home when fishing days are through,
Tonight, we dine, served food and wine, and dance away our rue.
Later we sleep, our souls to keep, while thanking for our lot.
Yes, we will pray, thanks for the day, and all of what we caught.

A Drink of Water

"Should the oceans, lakes and rivers all run dry, and likewise to the sea,
I'd fly out to the big dipper and bring a drink to thee."

Today I Traveled

Today I traveled to fetch a falling star,
and in my hast I went too far.
I traveled through the clouds and all that dwelled
And while I drifted aimlessly, another star fell.

In memory of Mary Banks who passed away on May 4, 2020.

Tomorrow the sun will rise and light us along our way,
But to me it brings sadness each and every day.
Our home ceaselessly echoes with the sound of your voice,
While memories abound, but for me there is no rejoice.
But there is hope and consolation once this life on earth is done,
For then we will be together in that place beyond sun.

The Rainbow

Today I saw a rainbow, half-rounded along the sky,
Its light was brightly heavy, and its presence did not seem so high.
Its majesty reminds me of what God had said one day,
"Never again by water, will man, with the earth, be slayed."

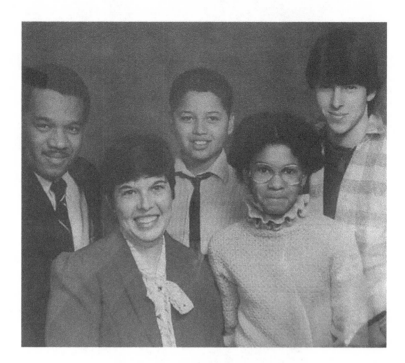

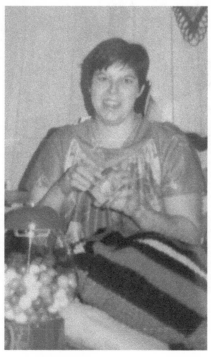

About the Author

E dward Banks is the first male born to a family of nineteen children, all born to the same parents. He was born in Wheeling, West Virginia, and has been a lifetime resident of Cadiz, Ohio. He was a six-year army reservist who did both basic training and advance individual training at Fort Polk, Louisiana. Edward spent thirty-two years in management positions while holding titles such as a maintenance supervisor, production manager, and director of operations in the health management industry. He holds both an associate degree in business management and a bachelor's degree in business administration. He is a forty-one-year licensed basketball official and once officiated both baseball and football.

Edward was married to Mary Louise Best of Hopedale, and they together raised three children: Michael, Eddie, and Amy. They now have eight grandchildren and four great-grandchildren. Edward's wife and granddaughter Penelope have both since passed away. Edward and his family are members of the First Church of Christ on Main Street in Cadiz.